Adobe Photoshop®

FOR UNDERWATER PHOTOGRAPHERS

JACK *and* SUE DRAFAHL

Amherst Media, Inc. ■ Buffalo, NY

To Kristy and Tommy—
Thanks for your continuous strength and support.
We love you guys.

Published by:
Amherst Media, Inc.
P.O. Box 586
Buffalo, N.Y. 14226
Fax: 716-874-4508
www.AmherstMedia.com

Publisher: Craig Alesse
Senior Editor/Production Manager: Michelle Perkins
Assistant Editor: Barbara A. Lynch-Johnt

ISBN-13: 978-1-58428-189-4
Library of Congress Card Catalog Number: 2005937371

Printed in Korea.
10 9 8 7 6 5 4 3 2 1

CONTENTS

Jack and Sue Drafahl are a husband and wife team of professional photojournalists, lecturers, and multimedia producers. For over thirty years, their articles have appeared in *Petersen's PHOTOgraphic, Rangefinder, Sport Diver, Skin Diver, Dive Training, Diver, National Wildlife Federation,* and *National Geographic World Magazine.* They have been actively involved in the digital transition since the early '80s and are software and hardware Beta testers for companies like Adobe, Applied Science Fiction, Corel, Kodak, and Ulead Systems.

Jack and Sue started their professional photographic careers at Brooks Institute of Photography in Santa Barbara, CA, where Jack later started the audio visual department. Both are active scuba divers, receiving their diving certification in the early '70s. Jack and Sue were awarded Divers of the Year from Beneath the Sea, and Sue is an inaugural member of the Women Divers Hall of Fame.

Jack and Sue make their home on the Oregon coast and enjoy teaching seminars worldwide on all aspects of photography, both topside and underwater. Recently, they have put their years of photographic experience to use designing the Oregon Coast Digital Center, an enhanced learning facility that features in-depth digital classes to help students better understand the digital realm. In addition to their various monthly articles, Jack and Sue are authors of *Digital Imaging for the Underwater Photographer, Photo Salvage with Adobe Photoshop, Step-by-Step Digital Photography, Advanced Digital Camera Techniques, Plug-ins for Adobe Photoshop,* and *Master Guide to Underwater Photography,* all from Amherst Media.

For more on the authors, please visit www.jackandsuedrafahl.com.

In a matter of a few short years, the underwater digital camera went from a novelty item to the predominant method for taking underwater pictures. Never before has a technology advanced so rapidly. Thanks to digital, though, underwater photography has evolved into a shoot-to-edit process. Rather than having to get each image just right as you did when using film, you now have the option of editing the image post-capture. Image editing programs make it easy to correct minor defects in your images, and Adobe Photoshop leads the pack as the most popular image editing software program.

Digital photographs are created with a digital camera (left) or by scanning film images to create digital image files (right).

Our very first book with Amherst Media was called *Digital Imaging for the Underwater Photographer*. It was introduced at the onset of digital, when most underwater photographers were scanning their film images and editing them in Photoshop. There were very few digital cameras on the market at that time, and only a few brave souls took their expensive digital cameras underwater. As you can see, times have definitely changed. There are now plenty of digital cameras and their corresponding underwater housings, and digital underwater photography has rapidly gained popularity.

Before *Digital Imaging for the Underwater Photographer* went into its second edition, we updated it and added several new chapters. Although its contents were enough to satisfy the new digital underwater photographer, we found that many underwater photographers had mastered all the editing skills the book had to offer, so we decided it was time for a sequel.

Adobe® Photoshop® for Underwater Photographers is your next step in mastering many of the powerful editing tools found in Photoshop. In the following chapters, we will present some of the more complex issues we have encountered over our past 35 years of diving and will show you how to correct common flaws using Photoshop's vast collection of tools. We will assume that you have already read *Digital Imaging for the Underwater Photographer* and have mastered the skills discussed therein, so we will minimize the repetition.

We also won't teach you the camera skills required for taking digital underwater photos as we have dedicated an entire book to the subject. *The Master Guide for Underwater Digital Photography* provides tips on taking better digital underwater photos, so be sure to order your copy.

We feel that once you understand how to fix the problems addressed in this book, you can utilize these tools and your newfound expertise to solve other unique problems. If you find that you encounter problems that are not solved in the scope of this book, log' on and drop us an e-mail (www.jackandsue drafahl.com). Now, give the page a turn. We hope you enjoy our book.

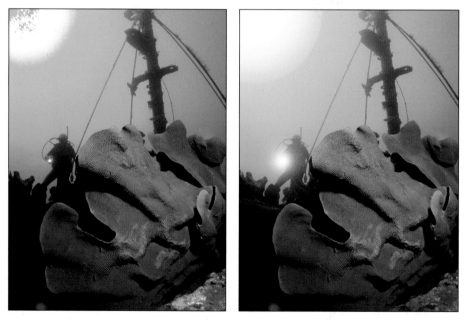

This flash-filled sunlight image of a wreck illustrates the shoot-to-edit concept. It is really difficult to expose for the sunlight and still get a good exposure for the flashlight. The solution is to shoot the image as best you can (left) and then modify the rest in Adobe Photoshop (right). The blooming effect in the upper corner was removed with a Gradient Fill and Lens Flare filter, and the flashlight beam was increased with the Lens Flare filter.

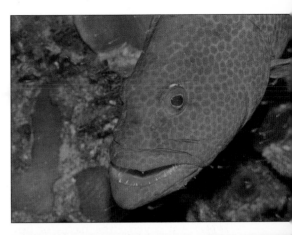

A common problem with digital cameras is improper exposure and color saturation. In this case, the fish is dark and very low in color saturation (right). The photo was easily corrected (below) with the Levels editor and the Saturation menu.

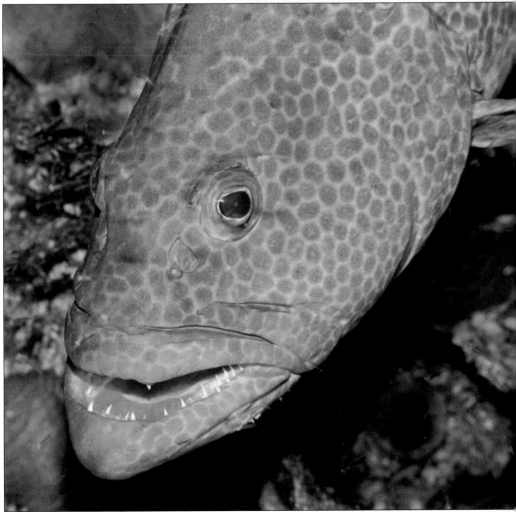

2. THE ADVANCED DIGITAL DARKROOM

Before we get into the real power of Photoshop, we need to address setting up your digital darkroom for editing underwater images. In chapter 2 of our first book, *Digital Imaging for the Underwater Photographer*, we covered the basics of how to set up your new digital darkroom. Since that time, computer technology has been changing even faster than digital photography, so there are no specific products or hardware we can recommend. Instead, we offer in this chapter a discussion of some features to consider and point out some new toys that will help make your digital darkroom more efficient.

O PROCESSORS

In order to edit your underwater images quickly and effectively you must have the fastest machine you can afford. It is not uncommon to see computer processors in excess of 2GHz, and computers with over 10GHz are just down the road. Dual processors are quickly becoming a standard feature.

Top Left—It is important to continuously hone your Photoshop skills. You might consider attending Photoshop classes at our school, the Oregon Coast Digital Center. The class size is limited to four students to guarantee personalized attention. For more information, go to www.oregoncoastdigitalcenter.com. *Bottom Left*—Most computers today have two or three slots for RAM. You should start with a 1GB RAM card and add additional cards as you need them.

○ RAM

Increasing the processor speed is only part of the solution, as you must consider RAM. Most computers at the time of publication come standard with either 512MB or 1GB of RAM and usually offer slots for expansion. We now recommend a minimum of 1GB of RAM—and more if you can afford it—when using Photoshop CS, CS2, and higher.

Photoshop often makes five or more copies of an image in memory as you are editing. When working with a 12MP digital camera image, this equates to about a 40MB file. So, a single working image could use as much as 2000MB of RAM! Then if you add on the memory needed for the operating system, your RAM allocation disappears quickly. When the computer runs out of RAM, it starts using the hard disk as a memory cache and slows to a snail's pace.

○ HARD DISK

The third factor that limits the speed of your editing system is your hard disk configuration. If you want an ideal editing system, we suggest you have three drives in your computer. The first drive should contain your programs and operating system, the second should hold all the images you are editing, and the third should serve as a backup drive for your photographs and as a scratch drive.

Another way to increase the speed of your editing system is to use ATA serial drives. This type of drive is much faster than the standard IDE drives and can often double the speed of a drive system.

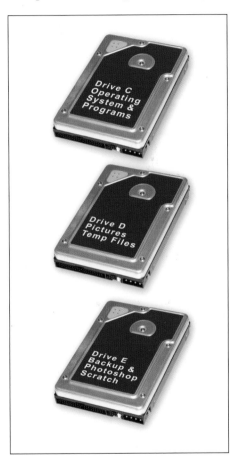

This shows a typical image editing system with three hard drives. Drive C is used for the operating system and programs. Drive D holds images and serves as a scratch (temporary) space for the operating system. Drive E is an optional drive used for image backup and also as a Photoshop scratch drive space.

○ MONITOR

The next consideration is the computer monitor. When in doubt, bigger is better: the larger the screen, the finer the image detail. As you move into monitors with resolutions of 1600x1200 and higher, you will find your images have a very smooth tonal value with no apparent pixels. The trend today is flat-screen monitors, and the larger ones needed for efficient image editing are indeed pricey. Don't worry though, because we have a cool solution.

Dual Monitors. As an alternative to large-screen editing, you can use two smaller monitors. When you open Photoshop, you can store all your tools, palettes, menus, and file manager on one monitor and use the other for full-

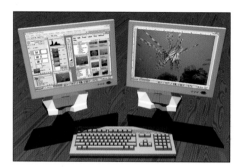

screen image editing. To move a menu from one monitor to another, simply use your mouse to grab the menu and drag it to the other screen.

Many of the new graphics cards support the concurrent use of dual monitors. Once you try dual-monitor editing, you'll be hooked for sure.

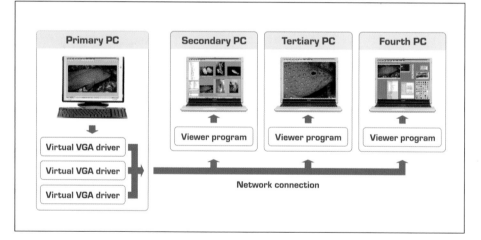

Top—The use of dual monitors is an effective alternative to working with one larger monitor. This type of setup requires a video display adapter that supports two monitors. With this setup you can put your menus on one screen and your image on the other. Above—If you have both laptop and desktop systems, an alternative dual screen option uses special software from MaxiVista. It links up to three laptops to your desktop system and allows you to drop images and menus from your desktop to the laptop screen and vice-versa. (Photo courtesy of MaxiVista.)

Using a Laptop. If you like the idea of dual monitors but don't want to buy another monitor, we have yet another solution. If you own both a laptop computer and a desktop system, you can use special software from MaxiVista (www.maxivista.com) to link the two computers through your network Ethernet system and magically you have a dual monitor system.

Monitor Calibration. Photoshop uses an image profile system that saves your monitor brightness, contrast, and saturation values in a special section of your image file. When that file is sent to another computer with the same profiling system loaded, it will convert the data so that the image looks identical on both systems. Monitor calibration is mandatory if you are serious about image editing.

In *Digital Imaging for the Underwater Photographer,* we briefly out-

One of the most accurate ways to calibrate your monitor is with a hardware device like the Spyder 2 from www.colorvision.com. This device works on both CRT and LCD flat screens. Its user-friendly interface takes you through the step-by-step process of creating your own color profiles for your monitor.

lined the need for monitor calibration for image consistency from one system to the next. We mentioned that Adobe's Gamma Loader program comes with Photoshop, but we have found the results are inconsistent and very subjective. We have since switched to hardware monitor calibration and have found it to be much more accurate. There are several types out there, but one of the more cost effective is the Spyder from Color Vision (www.colorvision.com).

These calibration devices are easy to use. Simply load the special software program that operates the device, attach the unit to your computer monitor, press the start button, and the software–hardware combination does the rest. Best of all, you can attach the unit to flat-screen or CRT monitors, and there is even an attachment so you can use it on your laptop computer. When the calibration is done, save the profile as the default for your monitor. Each time you start your computer this monitor profile will be loaded and used as you edit images in Photoshop.

Above—Adobe Photoshop upgrades about every two years, so most of the text and illustrations in this book are based on CS2 (Creative Suite 2). *Right*—You can set the preferences in Photoshop so that the new features of CS2 are highlighted.

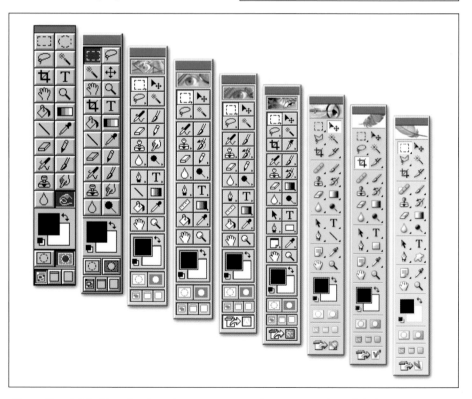

Upgrading Adobe Photoshop is an important part of keeping your digital darkroom up to date. This illustration shows the changes in the Photoshop toolbox from version 2.5 through CS2 (version 9).

○ SOFTWARE CONSIDERATIONS

Upgrades. One of the problems facing image editors today is the expense of the software and how often new versions come out. As a general rule of thumb, Adobe will come out with a new version of Photoshop every two years. Once you make the initial investment in Photoshop, you no longer have to pay the full price of the program as you can purchase upgrade versions for considerably less. We have been Adobe Photoshop Beta testers since the very beginning so we see all the new features ahead of time. If you are serious about image editing, then we would recommend upgrading every version as the time-saving new features are worth the investment.

AS A GENERAL RULE OF THUMB, ADOBE WILL COME OUT WITH A NEW VERSION OF PHOTOSHOP EVERY TWO YEARS.

○ PHOTOSHOP CLASSES

Photoshop can be quite overwhelming at first, so we highly recommend reading everything you can about it. Also, consider attending some Photoshop classes. We feel so strongly about the hands-on approach to learning the program that we founded the Oregon Coast Digital Center, an enhanced learning facility. Enrollment is limited to four students to maximize personal attention (www.oregoncoastdigitalcenter.com).

Another source of advanced Photoshop education can be derived from watching the Photoshop videos produced by one of the many Photoshop gurus. You can also join one of the many Photoshop-user groups on the Web to help find answers—and use relevant tutorials—to solve those nagging Photoshop questions. The Help function and the Photoshop manual are also excellent places to go for added information on a specific function.

3. TOP TEN EDITING TOOLS

P hotoshop has more than 700 tools, or variations of tools, that can be used to edit your underwater images. Fortunately, you will need less than a dozen to edit 95 percent of your images. Once you have become proficient in using these few but powerful tools, you will have mastered a big part of Photoshop.

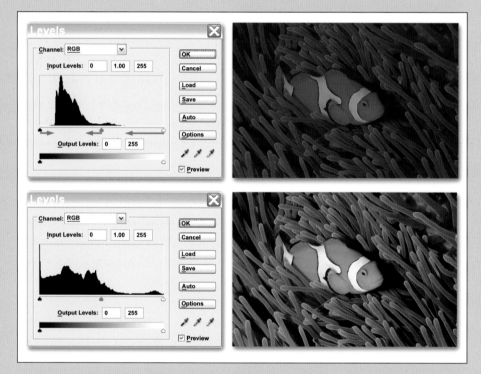

The Levels editor is the most commonly used tool for global image correction. The histogram pro-vides a graphic display of all the shadow, midtone, and highlight data contained in the image. The sliders (wedges) can be moved to readjust the gamma when necessary. Here we moved the left (shadow) slider to align with the data and change the shadows level. By moving the right (highlight) slider over, we corrected the dark highlights, and by adjusting the midtone slider, we increased midtone detail.

One interesting aspect of Photoshop is that almost every tool can be accessed several different ways. You may find that a tool can be accessed from a pull-down menu at the top of the screen, by using shortcut commands, or through other editing menus containing the tool. For example, the Levels editor can be accessed from the Image>Adjustments>Levels pull-down menu, by using the Ctrl/Cmd+L shortcut command, via Window>Layers, or by pressing the F7 button. (Note: Windows users will use the Ctrl button when executing these keystroke combinations, and Mac users will hit the Cmd key.)

If there is a function without a keyboard shortcut assignment, you can go to Edit>Keyboard Shortcuts or Window>Workspace>Keyboard Shortcuts & Menus and assign your own special key to that function (see chapter 4). You can also use a special feature called Actions to automate adjustments to an image. (We'll cover this topic in detail in chapter 4.)

After many years of editing underwater images, we have found that there are several tools that we use most often; we call them our "top ten tools," and in this chapter, we'll describe their use. In later chapters, we will be adding to these favorites as we work together on some of the more difficult problems encountered while editing underwater photographs.

○ LEVELS EDITOR

We all know that underwater photography presents its own set of problems. The nature of light as it penetrates the deep invariably yields photos with mid-tone detail that is too dark. For this reason, you will quickly find that you use the Levels editor more than any other function in Photoshop.

Before you start using the Levels editor, let's give you a refresher so you understand how it works and how to interpret it. When you open the Levels editor (Image>Adjustments or Ctrl/Cmd+L), you are presented with a histogram. The histogram displays all the tonal values in an image as it ranges from pure black (left) to pure white (right). If the data is evenly spread across the histogram, then you have a well-balanced exposure. If most of the data is on the left side, the image will be dark; if most of the data is on the right, the image will be very light or overexposed. Most underwater images have extensive data on the left, indicating that they lack both highlight and midtone detail.

Below the histogram you will find a black wedge (left), a gray wedge (center), and a white wedge (right). If you are missing data on the right, you can move the white wedge until it is under the leading edge of data in the histogram, making the lightest detail in the image pure white. If you have missing data in the shadows, just grab the black pointer and move it to the right so that it is positioned directly under the leading edge of shadow data. Photoshop will rearrange the data so that the darkest detail in the image is pure black.

Now let's suppose that you have a good black and white, but the image is still dark in the midtones. To make this correction, merely select the gray slider and move it toward the left while carefully watching its effect on your image. When you have achieved the desired tone and level of detail, release the pointer and save your midtone correction.

○ CLONE TOOL

The Clone tool is designed to copy and paste small amounts of data from one position to another. To remove a small artifact such as a backscatter particle, place your cursor over the area to be copied, hold down the Alt/Opt key, and click on that spot. The Clone tool then copies that data into memory. Move the cursor to the area you want to cover up, release the Alt/Opt key, click the

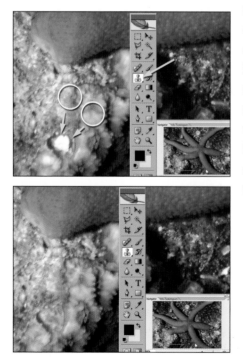

mouse button, and the preselected data will be copied onto that area. You can size the Clone tool by right clicking on the mouse or, better yet, use the "[" key for smaller Clone tool sizes and the "]" for larger. Alternatively, you can click on the brush icon at the top of the editing screen to select the desired shape and size for the Clone tool.

To eliminate a bright white spot like this one, select the Clone tool and place it near the bright area. By holding down the Alt/Opt key and clicking, the data under the cursor is copied. To paste the data to the new area, release the Alt/Opt key, move the cursor over the white area, and click.

The dead coral in this image was covered up using the Healing Brush. This brush works much like the Clone tool except that it also copies texture and shades of lighting. It usually takes several mouse clicks to fill in very bright areas.

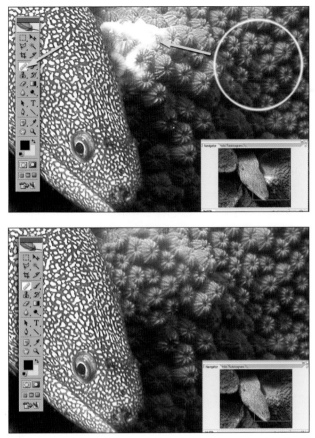

○ **HEALING BRUSH**

The Healing Brush was introduced in Photoshop 7 and works much like the Clone tool except that in addition to copying patterns from selected areas, it utilizes the brightness levels of its desired destination. This is a great tool for filling in spots of dead coral or light areas in an underwater scene.

Spot Healing Brush. The Spot Healing Brush found in Adobe Elements is now available in Photoshop CS2. This tool is great because it is a one-step correction process. You don't have to copy data since it pulls data from the area under your cursor and fills in the area with a single click. Merely set the Spot Healing Brush tool to a size larger than the area you want to remove and click the mouse. Since this new brush works like a Clone tool and Healing Brush combined, we use it more than the other two brushes for removing single specks of backscatter in an underwater image.

○ **SATURATION CONTROL**

Since most underwater subjects lose color either by depth or their distance from the camera, it is often necessary to adjust the image saturation. To open the Hue/Saturation palette, go to Image>Adjustments>Hue/Saturation or use the shortcut command, Ctrl/Cmd+U.

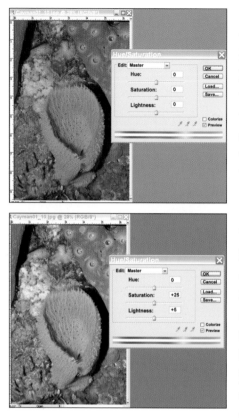

As you move the Saturation slider to the left or right it will decrease or increase the color saturation. With the Preview box checked, the image on the editing screen reflects the new saturation values so you can immediately see your modifications. Be careful when you use this tool—it is overused by many editors.

When the digital camera is some distance from the subject, the image can be underexposed and low in color saturation. This sponge was corrected using Ctrl/Cmd+W—the Hue/Saturation menu—and moving both the Saturation and Lightness sliders to the right until the image looked correct.

○ UNSHARP MASK

When an image is converted to a digital file via a film scanner or shot directly in a digital camera it tends to lose sharpness. Both film scanners and digital cameras have sharpening functions, but we recommend you either leave them at the default settings or just not use them at all. We find that the Unsharp Mask in Photoshop or some of the third-party sharpening plug-in filters do a better job. (See chapter 14 for more on the plug-in versions.)

When you open the Unsharp Mask from the Filter>Sharpen pull-down menu, you are presented with three settings. The Amount slider is used to set the amount of pixel contrast in an image. Generally, film images can be set from 100–200%, while digital can extend to 200–400%. The Radius slider setting determines how many pixels along a pixel edge are used for sharpening.

The Threshold slider is used to determine what level of pixel contrast should be considered an edge. When you set the Threshold value to 0, everything in the image is sharpened. As the threshold value increases, fewer pixels are sharpened if they exhibit little or no contrast change. The best way to use the Threshold setting is to initially set the Amount and Radius values, then move the Threshold slider to visually select your sharpness choice.

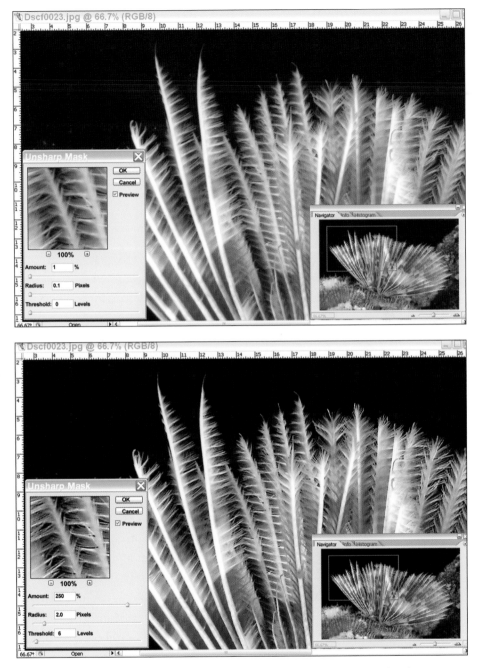

The Unsharp Mask was used to increase the sharpness in this image of a feather duster worm. The Radius was set to 2 for a 6MP image, the Threshold slider was set to 6, and the Amount was increased to 250 until the desired result was attained.

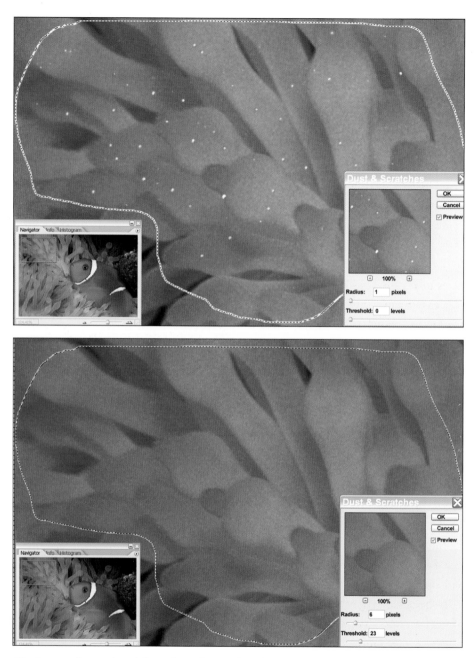

The Lasso tool was selected from the toolbox and used to draw around the area with the parti-
cles. The Filter>Noise>Dust & Scratches filter was then selected. Both sliders were set to mini-
mum, and then the Radius slider was moved until all the particles disappeared. The bottom
Threshold slider was then moved until the particles reappeared, and then we backed off slight-
ly until they disappeared again.

Photoshop CS2 introduced the new Smart Sharpen filter, which we think will eventually replace the Unsharp Mask as it is easier to use and does a better job of sharpening images. Amount and Radius sliders are available, and you also have control over the sharpness of the highlights and shadows. This filter is also located under the Filter>Sharpen pull-down menu. (For more information on this filter, see chapter 8.)

O DUST & SCRATCHES

The Dust & Scratches filter is found under the Filter>Noise pull-down menu. This is a very useful tool for underwater photography as many images will have white backscatter particles or small black particles on the digital camera CCD chip.

The best way to use this filter is to first select an area with these small particles using the Lasso tool. Open the Dust & Scratches filter and you will find two easy-to-use sliders. Initially set both the Radius and Threshold sliders to minimum. Slowly move the Radius slider until all the particles disappear. Don't worry about the image becoming blurred. Now move the Threshold slider until the particles reappear, then back off slightly until they disappear again. It's amazing how quickly and effectively this filter removes backscatter.

O CROP TOOL

Underwater photographers often tend to think only in the dimensions provided by their camera format. They will opt not to photograph a subject just because there are unwanted objects in the scene. You can now bring your image into Photoshop and crop the subject for the best framing of your animal. For example, if you have an image of a pipefish, you may want to crop it so that your final image is a long panorama. Don't be

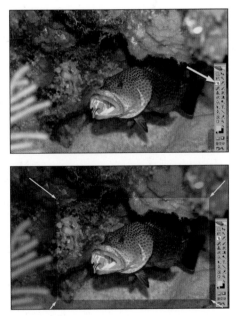

This image of a fish cleaning station degraded in image quality because of the out-of-focus area in the left foreground and another bright area in the upper right. The Crop tool was selected from the toolbox and used to crop out all the offensive areas.

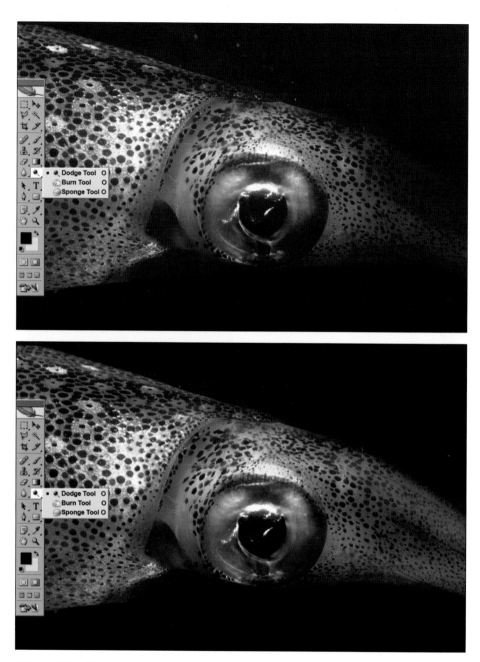

The squid in this image had good highlight data but was dark in the midtones and shadows. The Dodge tool was selected from the toolbox and slowly moved over the areas to be lightened. The Range setting at the top of the editing screen was positioned either for midtone or shadow correction, and the Exposure was set to 40% to provide more dodging control of the affected areas.

afraid to crop. Many times a so-so image becomes a dramatic winner with just a simple crop.

You might want to take another look at some of those images where the subject was a bit off to the right or left due to shutter delay. By cropping the image in an artistic way, you might be surprised with the results. You may quickly find that the Crop tool is one of your favorite Photoshop tools.

○ BURN AND DODGE TOOLS

At the very beginning of photography, burning and dodging was used in traditional darkrooms to selectively increase or decrease exposure in very specific areas. Burn and Dodge tools are also found in the Photoshop toolbox and are very handy for editing underwater images. When you select the Dodge tool, you can click on dark shadow areas and gently lighten them up. The Burn tool has the opposite effect and will darken small highlight areas in an image.

You can accurately control these two tools using the Exposure and Range settings at the top of the editing screen. The Exposure setting determines how much of the tool is applied. In most cases, it is best to set it to less than 50% and use several strokes to achieve the proper effect.

The Range control allows you to select the area to apply the Dodge or Burn effect. You can select from the highlights, midtones, or shadows. Generally you would use the midtone for dodging and the highlight to burn in detail. If you need to change the tool size, you can use the brush icon at the top, right click the mouse, or use the "[" key for a smaller brush size or the "]" key for larger.

WHEN YOU SELECT THE DODGE TOOL, YOU CAN CLICK ON DARK SHADOW AREAS AND GENTLY LIGHTEN THEM UP.

○ VARIATIONS MENU

The Variations menu, found in the Image>Adjustments pull-down menu, is useful in solving both color and exposure problems. When you bring up the Variations menu, the image is surrounded by color variations of red, green, blue, cyan, magenta, and yellow, which makes it easier to visually see the color shift. When you select an image variation from the outer ring that looks good, it will move to the middle. You can then select another one that looks even better or make coarse adjustments and corrections for shadows, midtones, highlights, saturation, and exposure. At the top of the Variations menu, you will see a side-by-side comparison of before-and-after corrections for critical analysis.

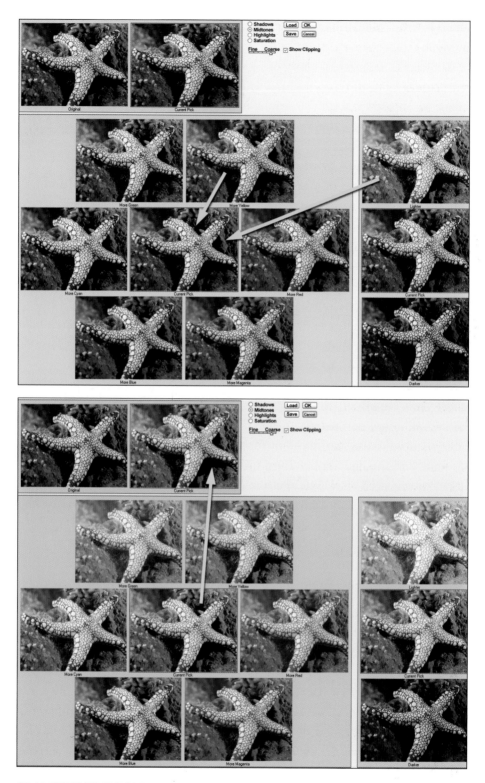

*Facing Page—This starfish image had an undetermined color shift, so the Image> Adjustments> Variations menu was selected with the midtone box selected. The Fine–Coarse slider was moved to the right until heavy color correction was apparent. The best color was the yellow, so it was selected. The lighter thumbnail was also selected from the right panel of exposure thumbnails. The newly corrected image is in the center, and the before-and-after thumbnails are shown at the top. **Right**—New layers that you add to the background image can be transformed in size, placement, rotation, and even formed into a new shape*

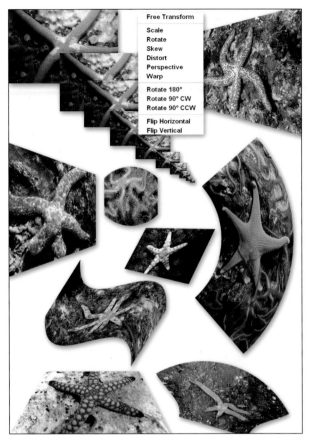

if necessary. If you want to maintain image quality in layers that you reduce in size, you should convert them to a Smart Object via Layer>Smart Objects>Group Into a New Smart Object.

If you have a group of images with the same problem, simply correct the first image, then open and close the Variations menu for each image and the same correction will be applied.

○ TRANSFORM

When you select any area in an image, or paste a new layer on an image, you have the option of transforming the selection or layer. This can be accomplished by going to Edit>Transform, pressing Ctrl/Cmd+T, or right clicking on the selection or layer. Once the Transform tool is activated, handles appear on the selected area so you can scale, rotate, flip, skew, distort, or create perspective with the selection. You are also able to grab the selection and reposition it on the background. If you want to scale an image and maintain its proportions, hold down the shift key and both x and y will increase or decrease

proportionally. Make sure you release the mouse button *before* the Shift key; otherwise, you will lose the aspect ratio.

Keep in mind that with Photoshop versions CS and older, reducing the size of the selection or layer will alter the object size (i.e., reduce the total number of pixels). If you decide to enlarge it later, the quality of the object will be compromised. With the introduction of CS2, objects can be converted to Smart Objects from the Layer pull-down menu. When you reduce the size of this Smart Object and then enlarge it later, it will maintain the resolution of its original size.

When you first start editing your underwater images, you might be discouraged to see how long it takes to edit just a few shots. As you become more proficient in editing, you will find that your speed will increase. There are also many hidden tools in Photoshop that can also help speed up the process and still allow you to maintain the best image quality.

○ KEYBOARD SHORTCUTS

Photographers new to Photoshop will often use the pull-down menus at the top of the editing screen to access the various menus. This can be time con-

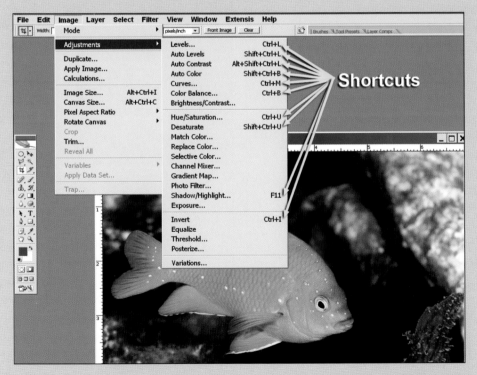

An easy way to see the shortcut commands for the pull-down menus is to look to the right of each command. If there is a shortcut, it will show the combination of keystrokes that will activate that command.

suming, as every time you need a menu, you must move your cursor to the top of the screen and move through menu selections before you finally open the one needed to edit your image.

If you look closely at the command lines in the pull-down menus and tool-box, you will notice that many have shortcut commands that open the menu quicker. For example, the Levels editor can be accessed via Ctrl/Cmd+L, Hue/Saturation via Ctrl/Cmd+U, Save via Ctrl/Cmd+S, Close via Ctrl/Cmd+W, and so on.

Some of the control shortcuts require the use of multiple key combinations, which are harder to remember. With the Edit>Keyboard Shortcuts menu open, press Summarize and a special web page format opens showing all the shortcut commands for your Photoshop version. Print out the sheet and use it to help you remember some of the more complex keystroke combinations. You can also see if certain keystrokes are not being used in case you want to design a customized shortcut for an often-used task.

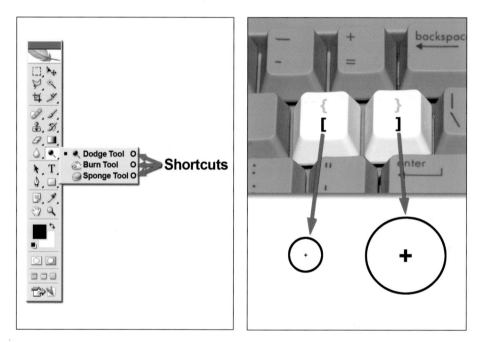

Left—*Toolbox shortcuts generally have a single keystroke command that allows you to select a particular group of tools. Once the group is selected, you may then have to click on the small wedge in the lower-right corner of the icon's box in the toolbar to activate a different tool.* ***Right***—*Brush size can be changed by right clicking the mouse, using the Brush palette, or by pressing the bracket keys. The left bracket ("[") makes it smaller, and the right ("]") larger.*

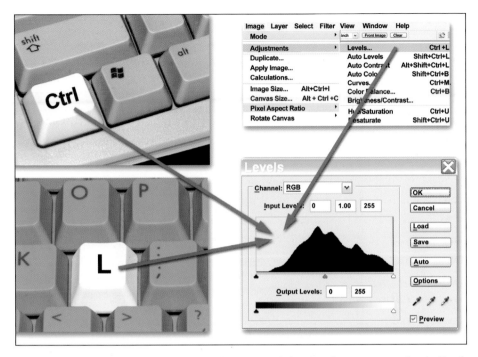

Most commands can be accessed in several ways in Adobe Photoshop. For example, the Levels editor can be activated by using the Image>Adjustments>Levels pull-down menu or the Ctrl+L keys. You can also access the Levels menu from the bottom of the Layers palette. See chapter 6 for more on the Layers palette.

○ **ADOBE BRIDGE**

A new file manager called Adobe Bridge comes installed with Photoshop CS2. To access this program, simply go to File>Browse, or use the Bridge icon at the top of the editing screen. You will quickly find that this is the hub of your image work area. With this file manager, you can look at sizable thumbnails of all your images, including those taken in the RAW camera file format. You can view the EXIF data, add personal information, batch process, rename, sort, and more. You can even set up the viewing area so that you can view your images in the filmstrip mode along the bottom or side of the screen. When you select a given image, it is enlarged in the middle of the screen for closer scrutiny.

If you are using a dual screen setup, put Adobe Bridge on one monitor and Photoshop on the other. No more going to the File>Open command as it is easy to drag images you want to edit from one screen to the other. Keep in mind that Adobe Bridge is a large program and it takes more time to operate than the smaller file managers you may have previously used.

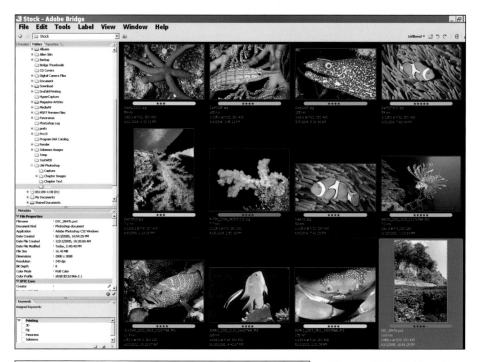

Above—*Adobe Bridge allows for quick access to all types of file formats for editing in Adobe Photoshop. Favorites, Folders, Metadata, Label System, and a Search Engine are all part of the program. Left*—*The Bridge Preferences menu allows you to assign data fields using metadata information. Here we have set the lines to include the file name, lens focal length, exposure, and the time the image was taken.*

▽ Camera Data (EXIF)	
Exposure	:1/125 s at f/13
Exposure Bias Value	: -1
Exposure Mode	:Manual
Exposure Program	:Manual
Brightness Value	:8.66
ISO Speed Ratings	:400
Focal Length	:10 mm
Focal Length in 35mm Film	:15mm
Date Time Digitized	:8/23/2005, 4:34:00 PM
Flash	:Fired, compulsory mode
Metering Mode	:Pattern
White Balance	:Auto
Contrast	:1
Sharpness	:Normal
Model	:FinePixS2Pro

The Metadata menu includes camera shooting data, editing facts, scanning information, and just about everything you wanted to know about your image.

○ **ACTIONS**

Actions are small programs that work inside Photoshop and combine several functions into one command that can be activated by pressing a Start button or executing a keyboard stroke. They are similar to the macro functions found in word processing programs. Photoshop comes installed with a large selection of actions that can perform various image and text effects to increase your productivity.

If there is a task that you constantly use, you can use the action recorder to create a new action. Simply open a single file, activate the recorder, and perform the necessary commands or operations. When you are done, stop the recorder, give the new action a name, and assign it a keyboard shortcut if needed. The next time you have an image that requires that special combination of tasks, select your action from the action palette and press the Start button. In seconds, your image is adjusted in the same manner as the original image.

Actions are so popular with Photoshop editors that Adobe has created a special section on their website called Adobe Studio. You can download thousands of actions, brushes, shapes, and tutorials for free once you have registered on the web page. One of the most popular actions on this site is an underwater action that performs miracles on monochrome underwater images that sport just a spot of color.

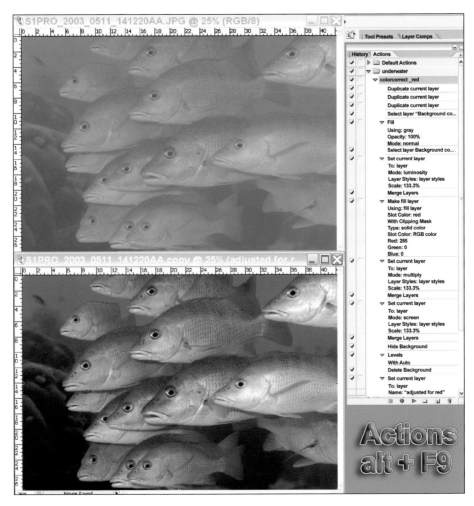

Above—The Actions palette allows you to apply one of thousands of Actions downloads from Adobe Studio (*www.adobe.com*)—or any you have created with the Actions recorder in Photoshop. A popular action for underwater photography is Underwater Color Correct Red, which can be downloaded from Adobe's web page. The key to this action is that your image must contain a tiny amount of color other than the blues found in available light images. *Facing Page*—This is a typical available light underwater image taken at Stingray City in the Cayman Islands. The off-colored image was loaded into Adobe Photoshop and corrected using the Underwater Color Correct Red action.

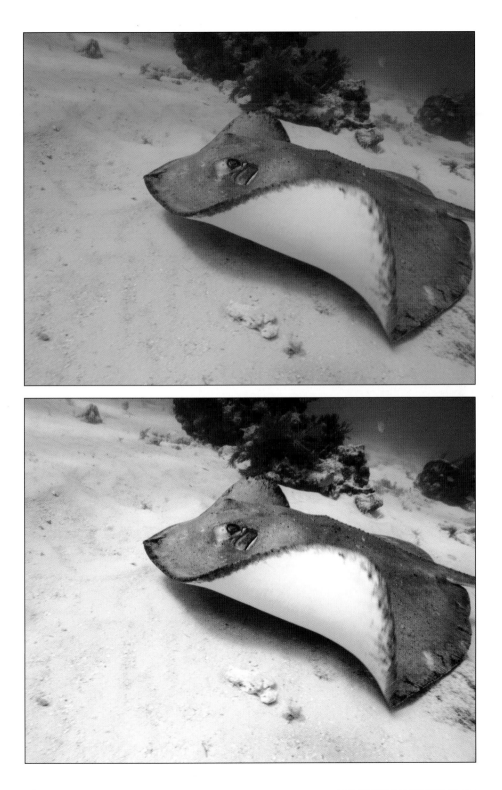

○ SCRIPTS

Scripts are a special set of commands that use Javascript, Visual Basic, or COM Automation to batch process images. Image Processor is a script that comes installed with CS2 and is found under File>Scripts. It is designed to batch process images by changing their format and file extension. As the file is being renamed and converted, you can also have an action applied to each file that is saved.

A fast way to batch convert files is with the File>Scripts>Image Processor command. You can save the files to the same directory or to a new one as JPEG, PSD, or TIFF and can even add an Actions command.

S uccessful Photoshop editing comes with knowing where to start when opening up your first underwater photo. Photoshop can tend to be a bit overwhelming, and you may find yourself lost in the maze of menus and editing tools.

Just as a physician in the Emergency Room must quickly evaluate each patient as they arrive during a crisis situation, you too must make a judgment call on each photo's treatment plan. There are both environmental and photographic variables that can contribute to the creation of a less than perfect image. The good news is that even with all these variables, most boil down to a half dozen problems that can be easily corrected in Photoshop.

The most common problems are exposure, color balance, color saturation, sharpness, dark midtone values, backscatter, and cropping. If you look at most underwater images edited today, 95% of them will fall into these categories. So, if you learn how to fix five or six common problems, you will quickly become pretty proficient at editing underwater images.

It is not uncommon for new image editors to become overwhelmed by the severity of some editing problems. The prospects of fixing up a complex image may seem hopeless, but don't give up. You may find that you are trying to make the process more difficult than necessary. Photoshop is a very powerful editing tool, and when used properly, it can solve some pretty big problems. We'll show you some tricks and tips on how to make the editing

Photoshop has dozens of palettes and pull-down menus that further expand into 700+ tools—which can be quite overwhelming and confusing.

process easier. When you see the potential of Photoshop, and how easy editing can be, you'll want to jump right in.

○ PHOTO GROUPING

One of the first things to do before you start your editing session is to group your images according to exposure and subject type. Once you have divided your images into close-ups, fish, wide angle, flash, or available light, you can then subdivide them based on exposure. Divide them into overexposure, normal, and underexposure categories. Move all these images into subdirectories or use the new file flagging system in Adobe Bridge.

Once you have grouped your images, pick one that best represents the group and edit that image. As you move from image to image within that group, you will find yourself using the same keyboard shortcuts and commands for most of the images. You can even design an action to perform certain functions that you find yourself repeating from image to image. All this speeds up the editing process yet maintains continuity of image editing within each group of images.

You can speed up the editing process by grouping your photos in different directories or by using the labels in Bridge. In this case, we created three groups: available light, flash fill sunlight, and macro photography. Each group of images requires similar editing solutions, so organizing your images in this way can save time.

○ TIME TRAVEL

The History palette can be an invaluable tool for correcting mistakes or moving backward through commands as it keeps a record of just about everything you do to an image. To display this menu, select the Window> History pull-down menu or click on the History palette tab. The default setting for Photoshop is to track up to 20 changes that you make to your image. When you go beyond the maximum states, the History palette will push off the oldest changes, always maintaining the 20 most recent changes.

If you use the Clone tool or Healing Brush often, you will find yourself quickly exceeding the 20

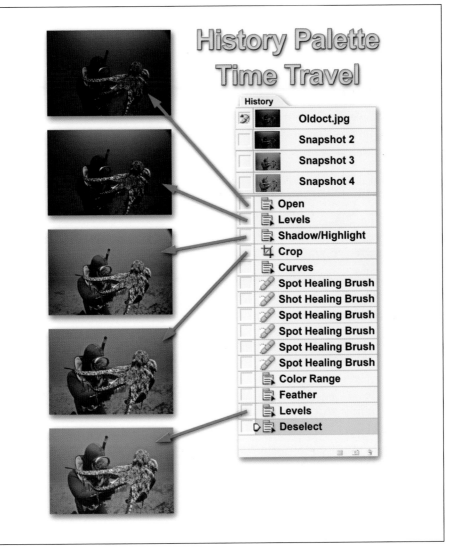

The History palette shows the progression of the editing process. We added the images on the left to show the results of the editing done in the History palette on the right. The top portion indicates snapshots created during the editing session.

changes. You may want to go to Preferences>General and set the History States to a higher number. Generally, we have found that with 512MB of RAM you should stay with the 20 state settings, but with 1–2GB of RAM, you can increase it to 40 or 60 states.

Even with added states, if you constantly exceed your History list, you can use the snapshot icon at the bottom of the History palette to save points in

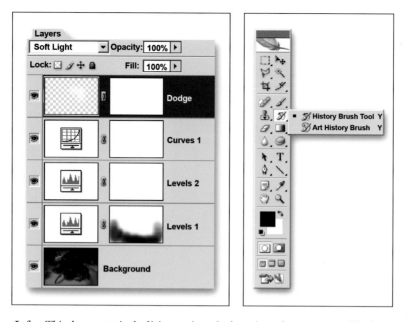

Left—This shows a typical editing session of a hermit crab on a sponge. The bottom image is the original file with two Levels edits—one with a mask—a Curves edit, and a Dodge layer to improve detail in the crab. Right—The History Brush is accessed from the toolbox and is just below the Brush tool. You can also select the History Brush by pressing the Y key as a shortcut.

time. If an item is about to be pushed off the History list, you can take a snapshot so it will not be removed. Just click on the black triangle in the upper-right corner of the History palette and select New Snapshot, or use the Create New Snapshot icon at the bottom.

If you want to go back to the beginning of your editing session, you can click on the thumbnail image at the top of the History palette and move back to square one. If you only need to back up a little ways, just select any of the earlier states and resume your editing. Be aware that all the steps you previously completed that are beyond that point will be deleted.

If you want to delete just one step and keep the others, use the small black wedge at the top-right corner of the History palette, choose History Options, and select Allow Non-Linear History. You can then select any History state, delete it from the list, and only its adjustment will be deleted from your image.

There will be times when you find that you don't like specific editing that was done at various times and is therefore spread throughout the History palette. The solution is to select the History Brush tool and selectively paint areas to remove portions of your editing. Click the box along the left column

of the History palette to set the source of the point in time to which you want to return. Select the History Brush from Photoshop's toolbox, (fifth tool down on the right) or use the shortcut key "Y" to call up this tool. Move the brush over the edited areas in the image you want to remove, and the History Brush will paint back in time. The size of the brush can be adjusted with a right click of the mouse or by using the left or right bracket keys.

Another very nice feature of Bridge is the ability to record all your editing sessions and save them with the file. This is accomplished by checking the

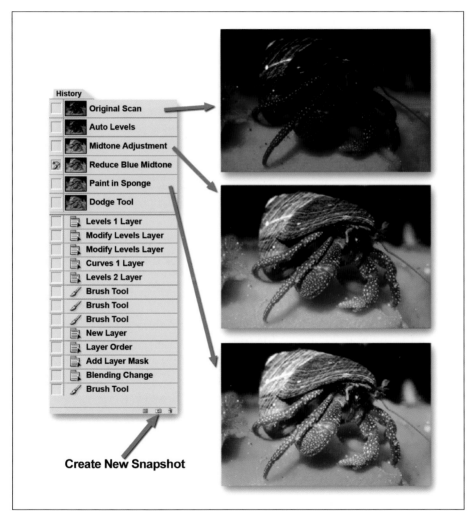

Create New Snapshot

If you double click on the name of a snapshot, you can rename it. You can also create a new snapshot and name it at any time by clicking on the middle icon at the bottom of the History palette.

```
                              Levels 1 Layer
                                  Make adjustment layer
                                      Using: adjustment layer
                                      Type: levels
                                      Adjustment: levels adjustment list
                                      levels adjustment
                                      Channel: composite channel
                                      With Auto Black & White
                              Modify Levels Layer
                                  Set current adjustment layer
                                      To: levels
                                      Adjustment: levels adjustment list
                                      levels adjustment
                                      Channel: red channel
                                      Gamma: 0.83
                              New Layer
                                  Make layer
                              Add Layer Mask
                                  Make
                                      New: channel
                                      At: mask channel
                                      Using: reveal all
                                  Select RGB channel
                                      Without Make Visible
                                  Select spot healing brush
                              Spot Healing Brush
                              Spot Healing Brush
                              Spot Healing Brush
                              Spot Healing Brush
                              New Layer
                                  Make layer
                              Add Layer Mask
                                  Make
                                      New: channel
                                      At: mask channel
                                      Using: reveal all
```

History Log
Save Log Items to: ○ Metadata
 ○ Text File Choose... D:\Document\Edit.log
 ● Both
Edit Log Items: Detailed ▼
 Sessions Only
 Concise
 Detailed

The Preferences for the History Log (lower left) can be easily accessed by using the Edit> Preferences>General tab to bring up the History Log menu. With the boxes checked as indicated, each file will save a history of the editing process to a directory on the hard disk. The history log (right) was extracted from the Metadata section of the file in Adobe Bridge.

History Log box in the Preferences section of Photoshop. Once you select this preference, whenever you save a file, Bridge will display the step-by-step editing process. This is especially handy if months later you want to know what editing steps were used to take an original camera file to the final image.

○ WORKFLOW

Transfer and Duplicate File. A digital camera file is your original image, so before starting any editing session, be sure to create backup files. We highly recommend that these files be written to CD or DVD so that they are separate from your hard disk and cannot be lost should your hard disk decide to crash. Since CDs and DVDs are very inexpensive today, we highly recommend that you make two copies of each of your archived digital camera files before deleting them from your hard disk.

PSD Files. When you open your underwater images in Photoshop, you should immediately save them as PSD files. All your image editing should be done on this PSD file rather than your original. Check the information on file naming conventions at the end of this chapter for more on this subject.

Crop. Extraneous objects such as overexposure areas or dead coral can have an influence on your image corrections. It is best that you crop your image before making any image corrections. Remember that if later you don't like your cropping decision, you can always go back to the original archived file and start again.

Full-Image Corrections. Global corrections to color, exposure, gamma, and contrast are done next using the various pull-down menus and submenus found at the top of Photoshop's editing screen. If you want to maintain these corrections for further editing, you should use the Adjustment Layers in the layers palette as it saves your corrections with the file. For more information on Adjustment Layers, see chapter 6.

Correcting Specific Sections. For working on smaller, specific sections in the image, you would use various tools from the toolbox. Corrections to specific sections of your images can be made using the Burn and Dodge tools, the Clone tool, the Healing Brush, the Spot Healing Brush, and various selection options. The selection tools can be used to restrict your work areas so other areas in the image are un-

THE SELECTION TOOLS CAN BE USED TO RESTRICT YOUR WORK AREAS SO OTHER AREAS IN THE IMAGE ARE UNAFFECTED.

affected. Once an area is isolated, you can use many of the global correction tools to adjust color, exposure, contrast, and gamma.

Sharpen the Image. The next step is to sharpen the image, and there are two directions you can go to accomplish this task. If you like maintaining everything in one final image, you can duplicate the Background layer and sharpen it separately using the Unsharp Mask or the Smart Sharpen function. The second option is to save your file twice, once unsharpened and once with the sharpen function added. This may often be necessary since you may need different levels of sharpening for different outputs. For example, you may use a higher sharpening level when making large prints and a lower level when sizing down the file for use on the Internet.

Save and Flatten. The final step is to save your file in the format you want to use. For example, you might save a file that is to be e-mailed as a JPEG, or leave it as a PSD if you plan to make a poster. Remember that if you don't want

Workflow

Transfer File to Computer

Archive Two Copies of File

Save PSD Working File

Crop PSD File

Make Global Corrections

Make Selected Corrections

Save Corrected PSD File

Sharpen and Save New File

*Left—This chart shows the typical progression for image editing workflow. **Below**—Various file naming conventions allow you to locate the different editing stages at a later date.*

dscn6490.jpg	EXIF original
dscn6490.psd	edit master
dscn6490L.psd	Layer adjustment
dscn6490S.psd	Sharpen
dscn6490F.psd	Final/Flatten

others to see your editing, you must go to Layer>Flatten Image. When you apply the Flatten Image function, it makes your final file smaller, but you cannot go back and modify your edits.

○ FILE NAMING CONVENTIONS

When you scan film images to your computer you will generally use a topic name followed by a sequential number. Digital camera files automatically save file names that will look like DSCF00012.jpg or DSCN00053.nef. When working in Photoshop with either type of image, you should make a duplicate file rather than editing the original file. That may sound like a pain, but neglecting to do so can cause you problems. Digital camera files save valuable

EXIF metadata, which can be lost when saving an edited file. If you make a change to a scanned image and find that you don't like it, you will have to take time to go back and scan the original image again.

Save as PSD. Instead, it is better that you set up your own file naming system so you can always find your original file quickly. The first step is to open your file and use the Image>Adjustments options to correct any problems in the image. Then save the file as a PSD using the original file name but with a PSD extension. The PSD files feature lossless compression and can be compatible with recent Photoshop versions if you select the compatibility mode. TIFF files, on the other hand, offer no compression and yield very large files, so we recommend that you stay with PSD.

Add a Letter. Sometimes you will save several variations of a file as you work through the editing process. We find it best to save the file using the original file name, but add a letter to the end for clarity. For example, if you were to edit a file using the Adjustment Layers, you could open a digital camera file DSCN0045.jpg, edit it in Photoshop, and save the file as DSCN0045L.psd. If you want to send the file out to someone, then you could use the Layer> Flatten Image command, then save the file as DSCN0045F.psd. Sure this type of editing will take more hard disk space, but considering that you can get a 250GB drive for just over $100, and a blank DVD costs about $.25, it shouldn't be a problem.

Find It Quickly. Later, when you need to find the original version of an image you have been editing, it is an easy process. Simply use the search engine for your data base, look for DSCN0045*.*, and you'll find your original file plus all the different versions. You can sort to see the order in which they were created and select the version that is best for your needs.

WE FIND IT BEST TO SAVE THE FILE USING THE ORIGINAL FILE NAME, BUT ADD A LETTER TO THE END FOR CLARITY.

Batch Rename. Should you decide to enter a photo contest and want to rename a file to better describe the imagery, here's how to do it and not lose access to the original file. Open Bridge (File>Browse), right click on your image, and select Batch Rename. In the new menu that appears, type in the desired contest name and check the box titled Preserve Current Filename in XMP Metadata. Make sure that you also check the box Copy to New Folder and give it a name and a location. When you open Bridge later to access the photo contest image, it will show the original file name in the metadata.

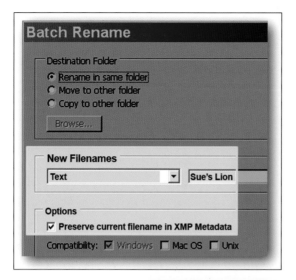

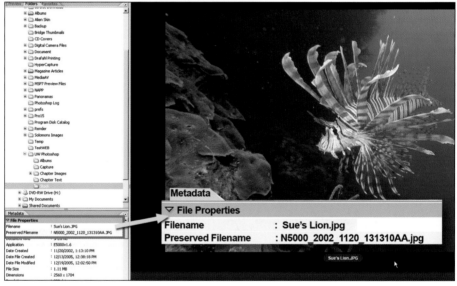

Top—Right clicking on files in Adobe Bridge will bring up the Batch Rename menu. If you want to rename a file and embed the original file name, make sure you check the box labeled Preserve current filename in XMP Metadata. **Above**—*When you rename files for a contest, you can always find the original file by looking at the file's metadata in Bridge.*

Throughout the remainder of the book we will show you a variety of methods for editing underwater images, and most will involve a type of editing that is called nondestructive image editing. Up until now, you have been using the toolbox and pull-down menus for all of your editing. Each action could be changed using the Undo (CS and older) or Step Backward (CS2) command, or by selecting an earlier state in the History palette. When you saved the file, even if it was in the PSD format, you couldn't go back and modify your changes. To re-edit the image, you would have to reload the original file to make your new changes.

In a nondestructive editing mode, you create layers that sit above the original image, and you make changes to just those layers. When you save the file as a PSD format, you can go back later and open the file to modify any of those original layer changes. The downside to this process is that the files are considerably larger and require more hard disk space. The upside is that hard disks are becoming larger and cheaper, so it's now easy to handle these larger, layered files. If you find that you constantly make additional changes or you spend extensive time editing specific images, you should use these nondestructive methods.

IN A NONDESTRUCTIVE EDITING MODE, YOU CREATE LAYERS THAT SIT ABOVE THE ORIGINAL IMAGE...

○ ADJUSTMENT LAYER BASICS

How Layers Work. The fastest way to access the Layers palette is via the F7 key. Just press this key, and the Layers palette opens. When you open a file in the Layers palette, it opens a Background layer that rests at the bottom of the palette. It is locked and cannot be moved unless you convert it to a layer (double click). When you add a new layer, it goes to the top of the chart. Layered effects all fall through from the top layer to the bottom (Background) layer.

At the bottom of the palette you'll see several small icons. If you press the circle that is half white and half black, a submenu opens featuring a large selec-

tion of image controls like Levels, Curves, Color Balance, and Brightness/ Contrast, to name a few. When you click on one of these adjustment controls, it makes an Adjustment Layer designed specifically for that function.

The only way to conduct nondestructive editing is to add a mask to each layer. When you add a mask using the Create a New Mask icon, you can finesse your adjustments with the Brush tool. Set the foreground color to black to remove your edits, and set the foreground color to white and use the Brush tool to restore them. (In later pages, we'll refer to this simply as using the "black brush" or "white brush.") You can vary the effect of the white and black brushes via the opacity setting at the top of the Layers palette. There are also blending modes, such as Soft Light, Hard Light, or Normal, so you can adjust just certain areas of the image.

You can also add a new layer using the New Layer icon. It automatically adds an icon for the layer and you can then add a mask using the Add a Mask icon. You can use this new layer to Clone, Heal, or Burn and Dodge the image.

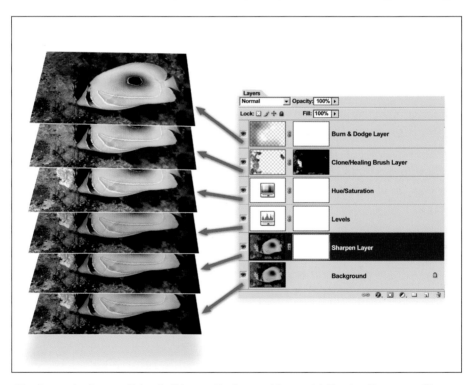

Nondestructive image editing builds on a Background layer with Levels adjustment, Clone or Healing Brush, Hue/Saturation, Burn & Dodge and Sharpen layers. The stack of images shows the progression of the image editing, and their corresponding layers.

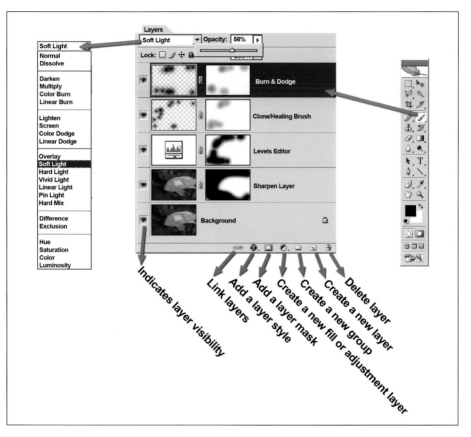

The Layers palette opens with the F7 key or via the Window>Layers pull-down menu. Layers are built from the bottom up, with the Layers on the left and the Layer Masks on the right. Blending modes for each layer can be accessed from the top of the menu. Masks are edited using the Brush tool; when it's used in black it erases the adjustment, and when used with white, the data is added back in. Various Layer commands are accessed from the bottom of the Layers palette.

Be sure that the Use All Layers option is checked when using a new layer so that the background data is copied to the new layer.

On the left side of the screen you will see an eye icon that indicates whether or not the layer is visible. Turning this icon on and off allows you to see the before-and-after effect of your Adjustment Layer.

There are also times when it is necessary to group layers so that you can move the effect. You can use the Group Layers icon to assemble similar layers.

Speeding up the Action. Adding layers to each image you edit takes time, but here's a way to speed up the process. We suggest that you make an Action to create all the layers you might need when editing. Here's how.

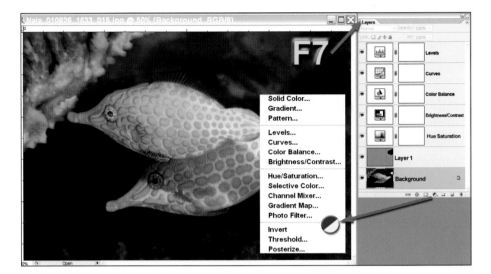

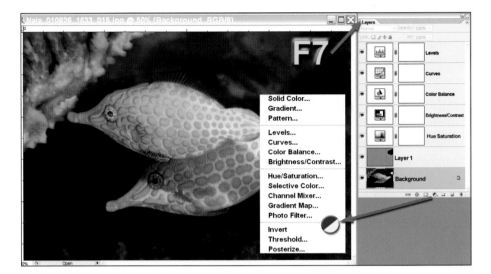

Above—*Layer adjustments can be selected from the bottom of the Layers palette by touching the icon with the small black and white half circle. Once you make your selection from this list, the Layer adjustment and its mask will appear in the Layers palette. *Left*—To speed up the process, you can record an Action to automatically add the five main adjustment layers. Just open a file and select each adjustment from the bottom of the Layers palette. Each step is then listed in the Action palette, and you can modify any section by double clicking on the thumbnail that represents that adjustment.*

Open an image and turn on the Action recorder. Now press the F7 key so the Layers palette opens. Go through and open all the different Adjustment Layers you think you might use when editing a photo. You don't have to make any adjustments, just say OK to each effect. When you have all the Adjustment Layers you want, add additional layers for the Clone tool and Healing Brush, sharpening, and burning and dodging before stopping the recording. We recommend that you then assign the F12 key as the shortcut command for your newly compiled Action.

Let the Action Begin. You now have a high-speed nondestructive editing system. The next time you open an image, press the F12 key, and this full set of Adjustment Layers will be added to your image. You can then double click on the adjustment you need and apply it to the image. When you are finished editing, you can save the file as a PSD and go back to edit it later. You will be amazed how much this will speed up your editing while providing more control over image quality. Image editing doesn't get much better than this!

○ CLONE OR HEALING LAYER

During the editing process you will find yourself continually using the Clone tool, Healing Brush, and Spot Healing Brush to help cover up imperfections. When you do this directly on the Background layer you can use the History palette when you make a mistake or need to change a correction. The problem is that even if you set the History palette to 40–60 states, you may make more corrections than the Step Backward command allows and will have to start your editing over.

YOU WILL FIND YOURSELF CONTINUALLY USING THE CLONE TOOL, HEALING BRUSH, AND SPOT HEALING BRUSH. . . .

Create a New Layer. The solution is to do your editing on layers so that the background image remains intact. Use the F7 key to open the Layers palette and click on the Create a New Layer icon at the bottom of the menu to add a new one. We highly recommend that you make all your image adjustments before starting the cloning and healing process. This way the Background layer is at the bottom, the Levels adjustment layer comes next, followed by any further Adjustment Layers. If you want to make additional adjustments to the image after you have completed your cloning or healing effects, add a second Adjustment Layer above your cloning layer. Layers take up very little memory, so you can stack as many as you want, or remove and replace layers to improve your image.

Layer Visibility. Use the eye icon in the Layers palette to turn layers on and off to see their effect. If you find there are areas in your layer editing that are ineffective, you can add a Layer Mask and use the Brush tool to remove or add data. Make sure that when you use the Brush tool you have the foreground color set to black to erase and white to add.

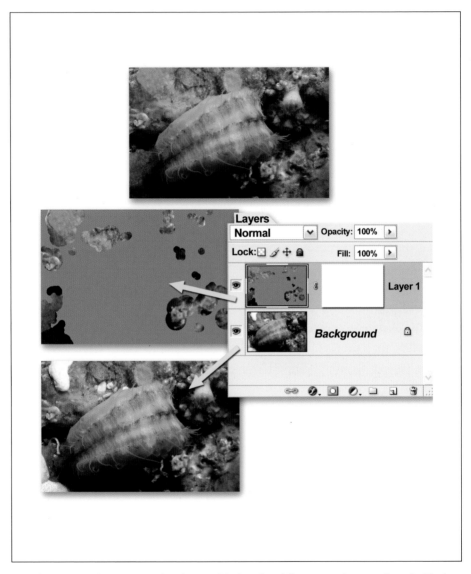

Nondestructive editing using the Clone tool is done by adding a new layer and mask. The bottom image is the original file, while the middle image shows the layer where we used the Clone tool. The top image shows the effect of the background and Clone layer together.

○ THE SHARPER IMAGE

The best way to sharpen an image is to use the keyboard keys Ctrl/Cmd+J to make a copy of the Background layer. You can then sharpen the duplicate layer without affecting the Background layer. At any time, you can turn off the eye icon in the Layers palette and see the original Background layer image for comparison.

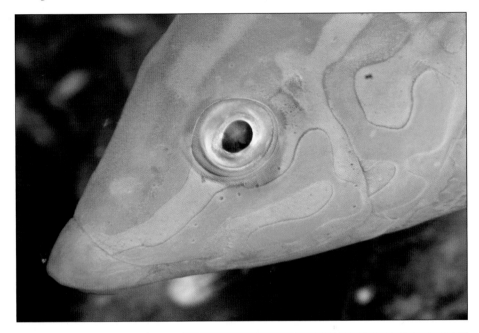

Above—This image of a fish was cropped tight to the head and eye so you can see how we can selectively sharpen parts of an image.
Right—The Layers menu shows the background image, a copy image, and its Layer Mask. The layer was sharpened with the Unsharp Mask, and a black brush was used to fill in all areas of the mask that we didn't want the Unsharp Mask to affect.

*Top—Original image cropped and zoomed to show lack of sharpness in the eye. **Above**—This is the screen display when you are working with a Layer Mask and click on the eye icon to turn the layer visibility off.*

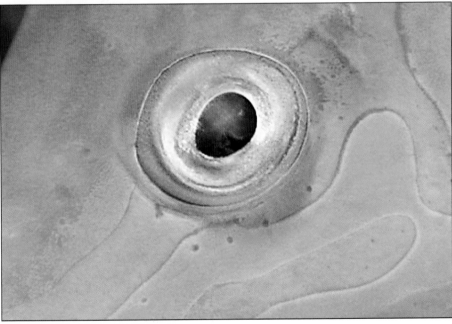

Top—To see the layer mask by itself, you first must turn off all the layers except the one with the mask. Hold down the Alt key, click on the mask, and it will appear by itself. Click again and the combined layer and mask will be visible. **Above**—This is the final image after the selective sharpening was accomplished using the techniques discussed.

Selectively Sharpen. If you want to selectively control the sharpening effects, you can add a mask from the Layers palette and use the black brush to remove—or reduce—sharpening in particular areas. This is often handy if the overall image needs no sharpening but an animal's eye could use a bit.

Going Back. If you sharpen the background image after you have made several adjustments to the image using Adjustment Layers, the result is virtually permanent. It can be reversed but you will find it very difficult to remove the sharpening effect and still maintain the adjustment. If you find yourself in this bind, load the original file, copy it to the clipboard, and then paste it into the layer version just above where the background was sharpened. This layer will cover up the sharpened background and still allow the effects of the Adjustment Layer above it. The previously mentioned method of duplicating the Background layer and then sharpening the duplicate is still the best choice.

○ BURNING AND DODGING TECHNIQUES

If you want to burn and dodge areas of an image and would like to be able to go back and edit the photo later, then you should copy the Background layer using the Ctrl/Cmd+J shortcut and use the Burn and Dodge tools on that duplicate layer. If you want to remove or reduce the effect on the layer, you can add a Layer Mask, and then use the black brush to create the desired effect.

The burning and dodging was done by adding a new layer and mask, and setting the blending mode to Soft Light. The black brush was then used to burn in several areas around the fish. A Levels Adjustment Layer was also added to correct the exposure of the fish, and a Clone/Healing Brush layer was added to remove some bright spots.

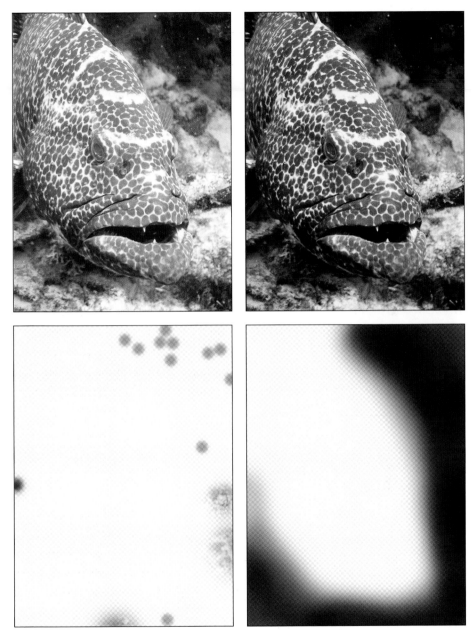

Top Left—*The tones in the background make it difficult to see the fish.* ***Top Right***—*The Levels Adjustment Layer was added to tweak the color and brightness of the fish.* ***Bottom Left***—*The Clone tool was then used to remove hot spots. This is the screen image when you turn off all layers except the clone layer. Sometimes this is helpful to fine-tune your cloning, or find areas to remove.* ***Bottom Right***—*A new layer and mask were added, and the Blending mode was set to Soft Light. A black brush was then used to burn the area around the fish. This is the screen image when you turn off all layers except the Burn & Dodge layer.*

Facing Page—This image shows the final fish portrait after several layer adjustments have been added.

Selective Editing. Should you desire more control over your burning and dodging, especially when working in large areas, make an area selection, and then add an Adjustment Layer. Photoshop will not only add the Adjustment Layer but will also add a special mask that restricts the adjustment to just the selected area. With the mask selected, you can then use the Brush tool set to black to reduce or remove the affected area. If you notice a slight line along the selection edge, you can use a Gaussian Blur filter on the mask to slightly diffuse the edges between the edited and non-edited area.

IF YOU WANT TO DODGE YOUR IMAGE, YOU COULD SET THE BRUSH TO WHITE AND DODGE ON THE SAME ADJUSTMENT LAYER.

Blending Modes. Another nondestructive editing approach requires that you first add a new layer (using the Create a New Layer icon at the bottom of the Layers palette) and then set the blending mode (found at the top of the Layers palette) to Soft Light. You can try some of the other blending modes, but we find that this one seems to work the best. You can select a black brush with a low opacity setting of 10–30% to stroke the areas you want to burn.

Use Separate Layers. If you want to dodge your image, you could set the brush to white and dodge on the same Adjustment Layer. Since these layers don't require much storage space, it might be better to make another new layer and use it just to dodge specific areas. This way you have one layer for dodging and a separate one for burning for maximum control. In order to keep the layers straight, double click on the name of the layer in the Layers palette and give it the proper label. If you want to remove portions of the burned or dodged areas from either layer, you can switch to the Eraser tool and use it to remove the editing.

○ ADVANCED LAYERING TECHNIQUES

When working with layers, you will have the most control when you combine the selection tools, Layers, and Layer Masks. Before you attempt this type of complex layer editing, you should have a good understanding of how to select portions of an image. We devoted an entire chapter to the subject in our book, *Digital Imaging for the Underwater Photographer.*

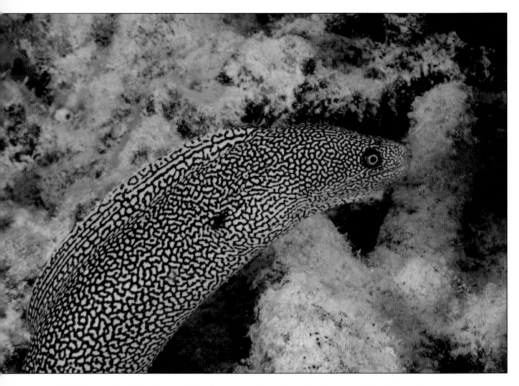

This image is off-color, and the foreground and the background blend together.

The tools you will be using for selection layers are the Lasso, Polygonal Lasso, Magnetic Lasso, and Magic Wand. You can also use the Select>Color Range pull-down menu option. If you are not familiar with this tool, you need to improve your expertise before attempting layer selections.

When working with selections, the key is to first select the area you want to adjust or modify. Feather the selection if you want, but keep in mind that you can blur the layer mask in the layer, which in effect accomplishes the same thing. Next, go to the Layers palette and make sure you have selected the Background layer or layer you are selecting from. Press the Ctrl/Cmd+J short-cut command to copy the selection to a new layer.

In the Layers palette, move your cursor over your new layer selection and right click on the thumbnail. Move down to Select Layer Transparency in the drop-down menu and click on it to add the selection marquee to that layer. Go to the bottom of the Layers palette and click on Add Layer Mask icon to add a mask to this new layer. With this mask in place, you can select a brush, set your foreground color to black, and paint away any portion of the layer that you don't want to use in your adjustments.

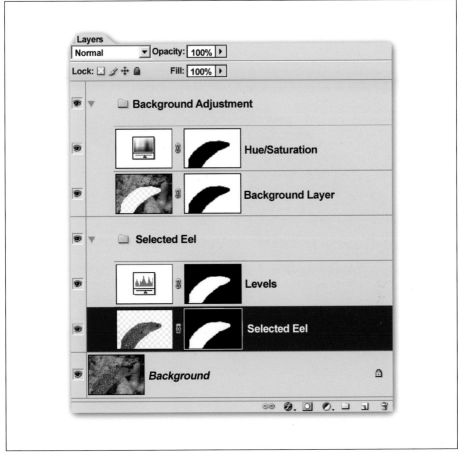

This screen shot shows the Layers palette with all the layer selections used in this exercise. The bottom thumbnail is the original image. Two groups were created to hold the foreground and background separately. The eel was selected using the Polygonal lasso and copied via the Ctrl+J shortcut so that it is the bottom image in the first group. We right clicked on the thumbnail and used the Select Layer Transparency command to load the selection back in. We selected the new mask to add a mask to this layer. We then activated the Select Layer Transparency command again, and added a new Levels Adjustment Layer from the bottom of the Layers palette. We adjusted the eel until it was the right brightness and color. We loaded the selection again, inversed the selection, selected the Background layer, and used the Ctrl+J shortcut to make a new Background layer. A second new group was created and the Background layer was dragged to that group. We right clicked on the new thumbnail and loaded the selection for that layer, then added a new mask to that layer. Loading the selection one last time, we added a Hue/Saturation layer from the bottom of the Layers palette. The lightness and saturation were modified so that the background was darker and more neutral, making the eel more visible.

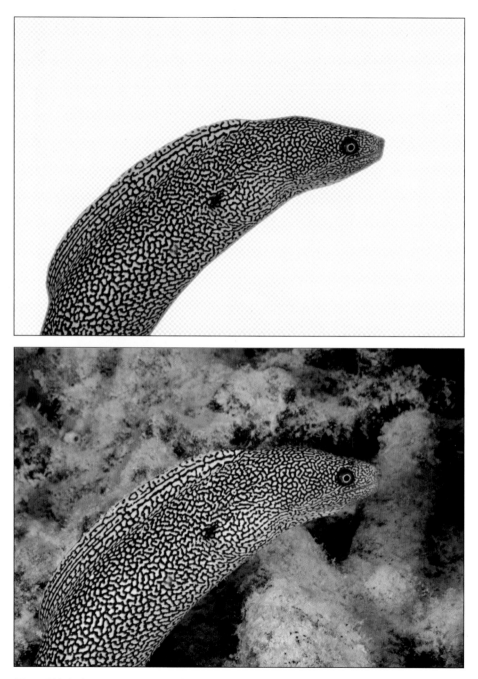

Top—*This is the screen preview of the eel layer with the background image turned off.* ***Above***—*This is a composite of the corrected eel on the background image.*

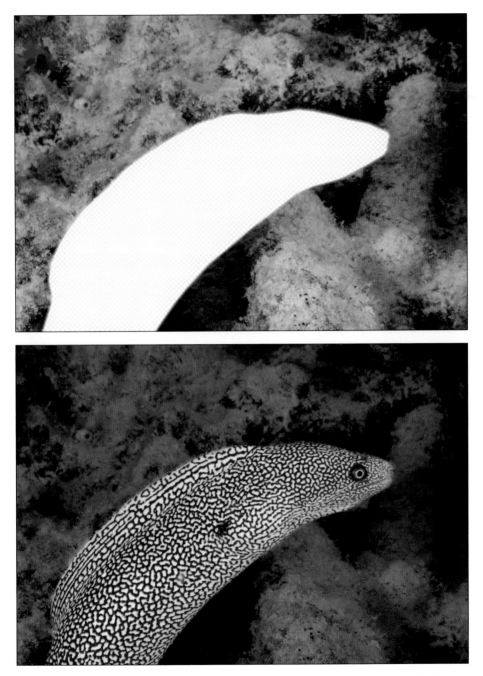

Top—*Preview image of background selection and mask with the eel image turned off.* *Above*— *Final composite image with all layers turned on.*

Choose the Select Layer Transparency option again, then go back down to the bottom of the Layers palette and click on the type of adjustment you want to make to the new layer. A new Adjustment Layer will then appear above the new layer with its own mask. You can now select this mask and use one of the Blur filters to blur the edges of the adjustment with the background image.

This same layer selection technique can be used with new layers created for the Clone tool, Healing Brush, or the Burn and Dodge tool adjustments discussed earlier in this chapter. Conducting this type of selective layer editing can make for a rather cluttered Layers palette, so we recommend that you create groups within the Layers palette and separate the different parts of the image into these group folders. This grouping concept works much like the tree and folder system found in Windows Explorer.

CREATE GROUPS WITHIN THE LAYERS PALETTE AND SEPARATE THE DIFFERENT PARTS OF THE IMAGE INTO THESE GROUP FOLDERS.

7. ADVANCED COLOR AND EXPOSURE CORRECTIONS

Whether you shoot film or digital, color and exposure are the two biggest problems you will encounter. This is due to the nature of the underwater environment and how it affects photography. Light refraction, time of day, water column, extreme flash falloff, and the angle of the sun all contribute to the problem. The good news is that Photoshop has several very powerful tools that can be used to combat these issues. Your tool selection depends strictly on personal preference and your editing skill level. There is no best solution, as they all work fine.

○ LEVELS EDITOR

The most popular tool for making exposure corrections is the Levels editor. It can be accessed multiple ways: from the Image>Adjustments>Levels menu at the top of the screen, the keyboard command Ctrl/Cmd+L, by pressing F7, and via the Create New Fill or Adjustment Layer icon at the bottom of the Layers palette. Once the Levels editor opens, a histogram displays the data for your image showing the shadows on the left, highlights on the right, and midtones in between.

Usually the first step in editing underwater images is to move both the right and left sliders to readjust any exposure problems in the highlights and shadows. You can then slowly move the middle slider to the left to increase the midtone detail in the image. You will notice that both the image on the screen and the histogram will reflect this new data arrangement.

The Levels editor can also be used to correct severe color shifts such as those found in available light images. Instead of using the RGB (default) composite setting at the top, you should access each individual channel and adjust the highlight, midtone, and shadow sliders until you have good exposure and color balance. Start with the red channel, and move the left (shadow) slider until the

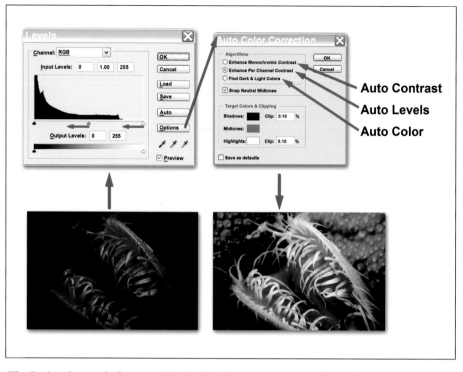

The Options box at the bottom of the Levels editor opens the Auto Color Correction menu. The three boxes at the top of the menu allow you to quickly move through Auto Contrast, Auto Levels, and Auto Color, without having to open and close each one to see the effect.

small wedge is positioned directly under the data. Then do the same with the right (highlight) slider and repeat the process with the other two channels. Go back to the red channel and move the middle (midtone) slider until you have corrected the blue shift that is a common problem with underwater images. You then may have to go to the other two channels and move the middle slider a bit to achieve the best color balance.

Eyedroppers. Another approach to using the Levels editor is with the three eyedroppers found in the lower-right corner of the Levels menu. If you know an area in your photo should be pure white, you can select the white eyedropper (located on the right) and click on that area. The entire image will then shift colors and Photoshop will create a new histogram that reflects this data change. The same goes for a black area if you use the black eyedropper (located on the left). If there is a neutral point in the scene, such as a scuba tank, you can try the middle eyedropper on that specific area to see if it will correct the color balance.

It should be noted that the eyedroppers work best on images with only a slight color shift. If you try them on images with severe color shifts, such as available light images, you may end up with an unacceptable posterized image.

○ Auto Functions

The fastest way to balance your image for color, contrast, and exposure is via the auto functions. You can access each option through two avenues. When you select any of these functions from the Image>Adjustments function at the top of the main editing screen, your image automatically adjusts the levels, contrast, and color, depending on your selection. If you are dissatisfied with your results, you must use the Undo or Step Backward command before trying one of the other auto functions. Remember that the Undo command allows you to go back one step at a time, and the Step Backward command works its way back through the history states.

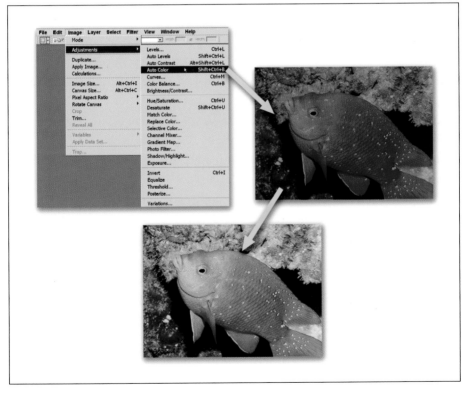

Quick and easy color correction can be accomplished by going to Image>Adjustments>Auto Levels. If it doesn't work, you can Undo or Step Backward and try more advanced color correction methods.

Options. An even faster way to use the automatic functions is to click on the Options button in the Levels palette. When you press this button, Photoshop opens an Auto Color Correction palette with three algorithms: Enhance Monochromatic Contrast, Enhance Per Channel Contrast, and Find Dark & Light Colors. The main difference you will find in using the Options selection method is that you can choose any of the three options and, if dissatisfied with the results, you can simply select the next one. You do not have to use the Undo or Step Backward commands, making this a time-saving feature.

The Enhance Monochromatic Contrast function is the same as the Image> Adjustments>Auto Contrast command found at the top of the main editing screen. This button adjusts contrast and provides little or no change to the color and gamma.

The middle algorithm in the list, Enhance Per Channel Contrast, is really Auto Levels in disguise. When selected, it will readjust the white and black points and midtone detail. There is also a box at the bottom of the palette that allows you to select this or any of the algorithms as the default correction that is applied when you select the Options function.

Find Dark & Light Colors accesses the same function as selecting Image> Adjustments>Auto Color. With this option, Photoshop will attempt to color balance both highlight and shadow, and then spread the remaining data in between those points.

○ CURVES EDITOR

If you find that the three algorithms accessed through the Levels editor's Options button don't provide adequate control for increasing the midtone levels, you can open the Curves editor. This can be done from the Image> Adjustments pull-down menu, via the keyboard command Ctrl/Cmd+M, or by pressing the F7 key, and then clicking on the Create New Fill or Adjustment Layer icon at the bottom of the Layers palette and accessing Curves.

Add Control Points. When this advanced menu opens, you are presented with a straight line that plots the photo's density versus exposure for RGB plus the individual color channels. To start your editing, click on the three areas where the vertical and horizontal grid lines and the curve line intersect. You can add more points later if necessary, but these three points will provide the most

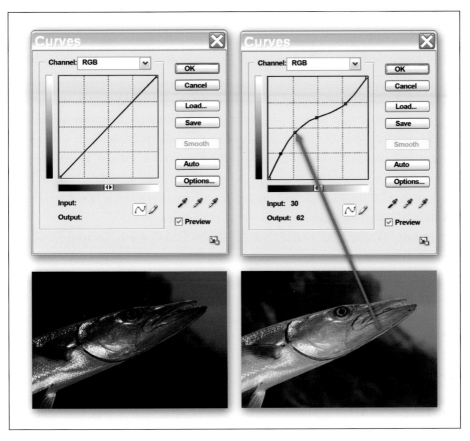

In the Curves editor, you can add points to the curve (which starts out as a straight line) and bend the line upward to increase brightness and detail or pull down to darken or decrease detail. You can also hold down the Ctrl/Cmd key and click on a specific point in the image to add its corresponding point to the curve.

midtone control. To increase the midtone detail, slowly move the bottom point up and to the left. You will note that the midtone detail will increase dramatically. Be careful not to go too far as you could get unnatural tonal values in the shadows.

Now move the top point down and to the right a little to protect and maintain the highlight detail. In most cases, you will move this highlight point less than the lower shadow point. The middle point generally is not moved as it is used as a pivot point.

Adjusting Specific Areas. Sometimes you will want to adjust a specific area in the image but won't know where that data falls on the curve. Hold down the Crtl/Cmd key and click on the area of the image that you wish to adjust.

Its position on the curve will show up so you can move and adjust that point. To give yourself added control when adjusting this area, place a control point above and below your selection point. The rest of the curve will remain intact as you make your adjustment.

Multiple Problems. When you have both exposure and color shift problems, you should first set the black and white points of the photo. It is very important that you select the most-black and most-white points; otherwise, the entire gamma range will be amiss. If the intended black and white areas are clear cut, then use the black and white eyedroppers to set each point. Sometimes it may be difficult to find the black and white points, so we'll show you another selection method.

Finding White and Black Points. Select the Eyedropper tool from the toolbox (located just above the Zoom tool). Now click on the Create New Fill or Adjustment Layer icon at the bottom of the Layers palette and select Threshold to add a Threshold adjustment layer. As you move the slider in the Threshold menu to the far left, you will see the deepest shadow area in the image. Hold down the Shift key, click on that point, and Photoshop will create a small crosshair with a number beside it.

Move the Threshold slider to the right, and hit Shift and click again to set the highlight point. When you exit the Threshold menu, your numbered crosshair points will show on the original even if you delete the Threshold layer.

This makes it easy for you to use the black and white eyedroppers on these points to adjust the full tonal range on the photographic curve. If there are no color shifts, you can click a point in the middle of the curve, and raise it or lower it to adjust midtone detail.

The Threshold layer is added to serve as an informational layer where you can find your white and black points in the image. When you have located the black and white points, turn the layer off by unchecking the eye icon to the left of the Threshold layer.

Available light images may respond dramatically and produce unnatural colors with the use of eyedroppers. If that's the case, then ignore the eyedroppers and use points on the curve to adjust both the exposure and color.

Color Shifts. If you have a color shift, you should go to the top of the Curves editor and select the affected

Top—With the Threshold layer turned on, move the slider to the right until a small amount of data remains. To show how it works, we pasted an onionskin of the original image over the Threshold layer. When you find the best highlight, select the Eyedropper tool, press Shift, and click the mouse to set its location. Bottom—To find the black point, move the slider to the left until a small amount of data shows on the screen. We placed an onionskin overlay so that you can see the relationship of the shadows to the original image. When you find the shadow area, select the Eyedropper tool from the toolbox, press Shift, and click to set the black point.

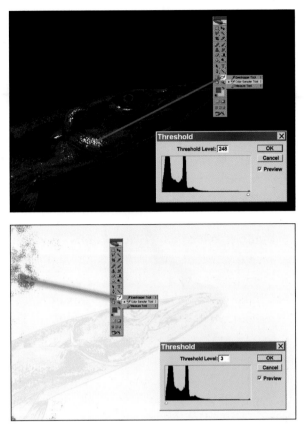

channel. Click on the middle or lower end of the curve and move it up or down in an effort to correct the color shift. For example, you might have an available light image that is flat and has a bluish shift. To eliminate the problem, you would first set the black and white points as described above, and then select the blue channel. Place a point in the mid-lower section of the curve and drag it downward. You will be able to see an immediate change.

○ SHADOW/HIGHLIGHT

More recent versions of Photoshop have a new tonal control called Shadow/Highlight, which is found in the Image>Adjustments pull-down menu. When this menu opens, you are presented with Shadow and Highlight sliders. You will note that the shadow adjustment is automatically set to provide 50% more midtone detail. This default setting can be adjusted; a higher percentage will increase the midtone detail, and a lower percentage will decrease the amount of midtone detail.

The Highlight slider is set to 0%, but the setting can be increased or decreased to adjust the exposure in the highlights. If you have specific levels that you use on a regular basis, you can save them as a preset and load them any time you have a new image with a similar problem.

More advanced image editors can click on the Show More Options box to make additional adjustments for the Tonal Width and Radius of both the shadows and highlights. Adjustments for Color Control and Midtone Contrast are found here as well.

The default settings in the Shadow/Highlight menu will generally get you very close. Tweak the Shadows with the sliders at the top of the menu, and adjust the Highlights from the middle of the menu. The bottom two sliders provide additional control over color correction and midtone contrast. You may need to experiment with each of the sliders to see how they affect the different aspects of the image.

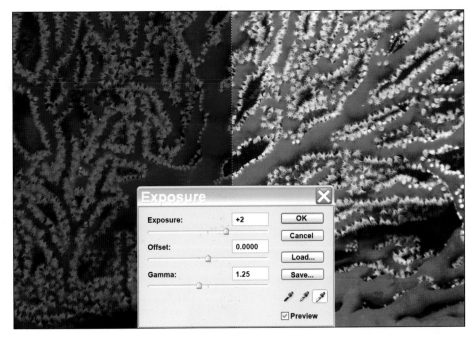

Move the slider for the Exposure, and you will immediately see the overall effect on the image. The Gamma slider is used to adjust the gamma of the image, either up or down. The middle slider effectively offsets the contrast problems that may arise when you adjust the top and bottom sliders.

○ EXPOSURE

New to CS2 is the Image>Adjustments>Exposure menu. This small and simple menu can be a very powerful tool for correcting midtone detail problems. The Exposure (top) slider works much like the exposure controls on your camera. Both shadow and highlights increase in Exposure Values (EV) so that +1 equals a 1-stop exposure increase and -2 reflects a 2-stop underexposure.

The bottom slider adjusts the Gamma of the image and has a default setting of 1, indicating no change to the image. A Gamma setting of less than 1 increases shadow detail, while a value above 1 decreases shadow detail.

The Offset slider (middle) causes both the Exposure and Gamma to be biased darker (left) or lighter (right).

○ SELECTIVE MIDTONE ADJUSTMENTS

Some images have a nice midtone range except in one or two areas. In this case, the Dodge tool offers the best solution. The key to effectively using this tool is to set the Exposure to 50% or less and use several strokes to slowly increase

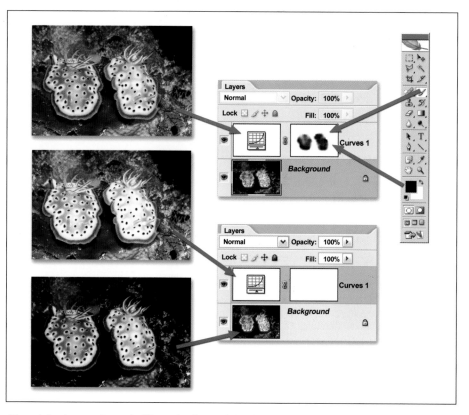

The original scan of two nudibranchs (bottom) has high gamma and contrast problems. When you add a Curves Adjustment Layer (middle) the highlights in the nudibranchs are still blown out. If you select the Curves editor mask, you can use the Brush tool, set to black, to block the effects of the Curves editor on the center of the nudibranch and allow the background detail to show through.

detail in the desired area. You will also note that next to the Exposure setting, there is a drop-down box that allows you to limit the effect of the Dodge tool to the highlights, midtones, or shadows. If you are trying to increase shadow detail, you should probably use the midtone or shadow setting. Try both to see which works best for your image, and Step Backward or use the history palette if you need to try another option.

○ Brush Tool and Layers Mask

Another way to fine-tune Adjustment Layers is with the Brush tool. Make your initial image corrections with the Levels editor, then select the mask assigned to the Levels Adjustment Layer. Set your foreground color to black and the

background to white. Slowly brush those areas in the Adjustment Layer where you don't want the effect applied. You can vary the brush size to minimize (or maximize) the scope of your adjustments. Minor adjustments can be made by setting the Opacity (top of screen) to 10–30%. If you make a mistake and need to reverse the effect of the Brush, switch the background and foreground colors and brush away the error.

○ HIGH DYNAMIC RANGE

Another new feature in Photoshop CS2 is the High Dynamic Range function. Found under the File>Automate>Merge to HDR pull-down menu, this powerful feature takes the same scene at different exposure levels and combines them into one image offering a very broad exposure range with increased midtone detail. It's very hard to get a registered exposure bracket underwater, but the HDR function has an Auto Register feature, so it might be worth a try if your subject and camera are steady.

This feature works extremely well topside with a tripod or fast bracket speeds. This is a great tool if you have an extreme lighting situation—for instance, when you want detail inside a building and still want to maintain good exposure in the sunlit windows.

Once the images are combined, you will have 32-bit images that can be converted to 8- or 16-bit images. You will then be presented with a second menu allowing further corrections of the highlight and midtone detail.

THIS POWERFUL FEATURE TAKES THE SAME SCENE AT DIFFERENT EXPOSURE LEVELS AND COMBINES THEM INTO ONE IMAGE....

○ CROSSOVER COLOR SHIFTS

When you shoot in shallow water, the combination of available light and flash cause a common color problem called a crossover. This is especially a problem with digital cameras, as they try to overcome the color shifts, creating more problems (warm colors fall in the shadows in front of the subject, and cool colors fall behind the subject). No matter how hard you try, it is almost impossible to balance both areas.

Hue/Saturation. You noticed that we said "almost impossible." The first step to balancing the two opposite colors is to select the warm color shift in the foreground. This can be done with the Magic Wand, Lasso tool, or the Select> Color Range function. Once you have the area selected, use the Select>Feather function to blend the edges of your adjustment with the rest of the image.

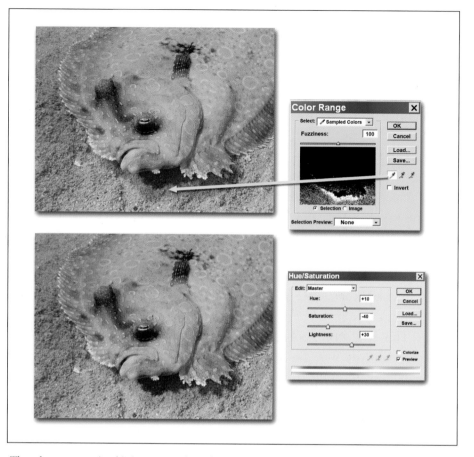

The color crossover in this image can be reduced by opening the Select>Color Range menu and touching the shadow area under the head of the flounder. Click OK, and open the Hue/Saturation menu with the Ctrl+U shortcut. Move the Saturation, Hue, and Lightness sliders until the color crossover is eliminated.

Open the Image>Adjustments>Hue/Saturation menu (Ctrl/Cmd+U) and move the Saturation slider to the left until most of the warm color has been neutralized. Now move the Hue slider slightly to the left or right to match the adjoining colors. Move the Lightness slider to match the surrounding areas.

Replace Color. Another approach to solving the problem is to use the Image>Adjustments>Replace Color command. When you use this feature, you don't need to select the area to be adjusted in advance. When the menu opens, you can use the eyedropper to select your work area and tweak your selection using the Fuzziness slider. You can then use the same slider adjustment that you used with the Hue/Saturation solution mentioned above.

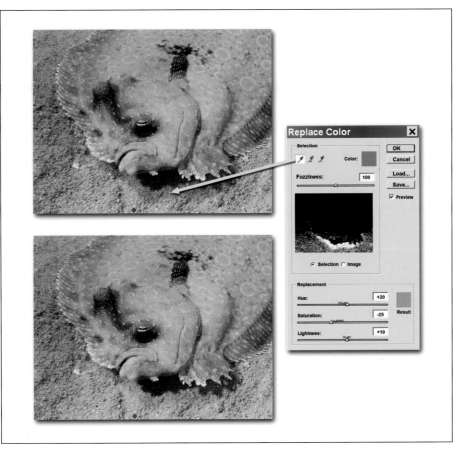

The Image>Adjustments>Color Replace menu works much the same way except that the entire process can be done within one menu. Select the area under the flounder's head, then use the adjustment controls until you are satisfied with the results.

○ GREEN WATER TO BLUE

When diving in shallow water or in poor visibility as when wreck diving, there will be times when the water turns green. Since divers find the water color of choice to be blue, there needs to be quick solution to shift colors without altering the subject. There are several solutions, so we'll look at the top two.

Replace Color. The first method uses the Image>Adjustments>Replace Color command. When this menu opens, you will be presented with a black & white thumbnail of the colors to be selected. Using the Eyedropper, work on selecting your colors on either the thumbnail or the original photo. If you find you haven't selected the entire color, you can use the "+" eyedropper, or hold down the Shift key to add to your selection. You can further tweak your selec-

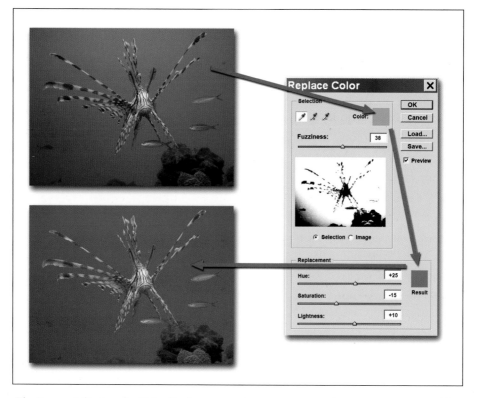

The Image>Adjustments>Color Replace menu is a great way to change green water to blue. Simply use the eyedropper to select the green water, and move the Hue slider until the water changes to a color you like. If you find that you have not selected enough of the green water, you can move the Fuzziness slider to the right, or use the "+" eyedropper to add more green to your selection.

tion amount with the Fuzziness slider at the top of the menu. Move the Hue slider slightly to the right and you will see the water change from green to blue. You can then adjust the brightness and saturation of the selected color using the other sliders.

Channel Mixer. A second, more accurate method for background changes is made by accessing the Image>Adjustments>Channel Mixer menu. At the top of the menu you'll see the Output channel listed, with sliders for the Source Channels—Red, Green, and Blue. To start the process, select the Green Output channel, then move the Green Source slider to the left until the green water turns blue.

Other neutral and opposite-color objects will shift toward magenta. To solve this problem, move the Red Source slider to the right until the shift is fixed.

○ Black & White Conversions

There will be times when no amount of color correction will repair a monochrome blue or green image. If you have no other uses for this image, consider converting it to black & white.

Grayscale. The fastest method is to go to Image>Mode>Grayscale and discard all the colors. If you decide to go this route, you should use the Auto Contrast feature to readjust the contrast range, taking it back to normal. You will be amazed how this function allows you to salvage some images that were destined for the trash can.

Split Channels. There may be times when a straight black & white conversion doesn't solve the problem. Your next solution is to go to the Channels palette and select the small black triangle in the upper-right corner of the menu. Drop down and select the Split Channels. Each of the three color channels will be converted to a black & white image and displayed on your editing screen. Pick the black & white channel image you like best, and throw the rest away. Be aware that if you are working with multiple layers, you will need to flatten your image before splitting channels.

The easiest way to change your color images to black & white is via the Image>Mode> Grayscale command found at the top of your editing screen.

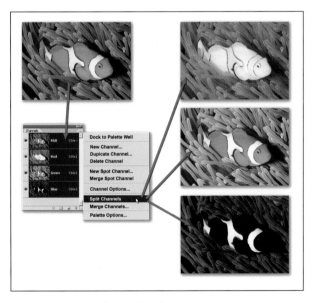

If you have some dramatic colors in an image you want to convert to black & white, you might try opening the Channels palette. When you expand this menu, you can select Split Channels, and Photoshop will create black & white images from each individual channel.

To achieve maximum control over your color to black & white conversions, open the Image> Adjustments>Channel Mixer menu. It works much like the Image>Mode command, except that you can change the tonal percentage in each channel before it creates a black & white image.

Channel Mixer. If you have an image with considerable color variations but you still want to convert it to black & white, you should consider using the Channel Mixer like we did to change green water to blue. At the bottom of the Channel Mixer menu, you will see a monochrome box. Checking this box converts the image to black & white. The difference is that you can still vary the red, green, and blue values of the original image to provide just the exact tonal balance you desire. This function is much like the Channel Splitter, except that you can mix channel colors to achieve hundreds of variations.

Selective Color. If you want to have a colored subject on a black & white background, you can open the Layers palette, add a Hue/Saturation Adjustment Layer, and reduce the Saturation to zero. You can then click on the mask thumbnail on the Hue/Saturation Adjustment Layer and use the black brush to paint back in the colored object.

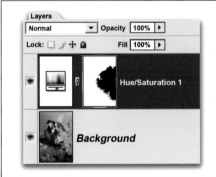

The creative combination of color on a black & white image can be created by adding a Hue/Saturation Adjustment Layer from the Layers palette. Move the Saturation slider to 0 so there is no color in the image. Select the mask to the right, and use the Brush tool, set to black, to paint on the mask to allow the background color to show through.

8. ADVANCED SHARPENING TECHNIQUES

One of the downsides to digital imaging is that scanned film images and digital camera images lose some image sharpness in their creation. Some of that sharpness can be reclaimed in the camera or film scanner, but in most cases, digital editors want a greater degree of sharpness than that option allows.

In our second edition of *Digital Imaging for the Underwater Photographer,* we presented several options for sharpening your images using Photoshop's Unsharp Mask and the plug-in filter from Focus Magic (www.focus magic.com). The introduction of new tools and techniques since that time necessitates the addition of an entire chapter on the subject.

○ SMART SHARPEN

With the introduction of CS2 comes the new Filter>Sharpen>Smart Sharpen filter, which we think will eventually replace the Unsharp Mask. The interface is easier to use, and it does a better job sharpening images. There are adjustment sliders available for setting the amount of sharpness and radius size, and there are also separate highlight and shadow controls.

THE RADIUS DETERMINES THE NUMBER OF PIXELS SURROUNDING THE EDGE PIXEL THAT WILL BE AFFECTED BY THE PROCESS.

Various Adjustments. The Amount slider sets the degree of sharpening that is applied to the image. The higher the number, the more the contrast increases between the edge pixels, giving the appearance of greater sharpness.

The Radius determines the number of pixels surrounding the edge pixel that will be affected by the sharpening process. The greater the value, the wider the edge gets, and it becomes more obvious.

At the bottom of the menu, you have a field named Remove, which offers three additional choices. Gaussian Blur uses the same sharpening technique as the Unsharp Mask filter. Lens Blur detects the edges and detail in an image and provides finer detail sharpening and reduced halo sharpening. The Motion

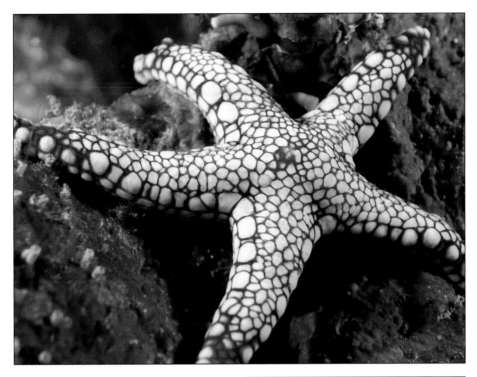

Above—*This original digital camera image of a starfish was taken in the Solomon Islands.*
Right—*(Top) This enlarged section of the image shows a loss of sharpness. (Bottom) Here is the same enlarged section of the image after applying the Smart Sharpen filter set to 100% with a Radius of 3 and using the Remove Lens Blur function.*

Blur option attempts to reduce the effects of blur due to camera or subject movement.

Advanced Settings. The Smart Sharpen filter also provides advanced settings that provide additional control over the highlights and shadows. Click on the Advanced button to access the Highlight and Shadow folders, which will allow you to adjust the amount, width, and radius of the sharpening.

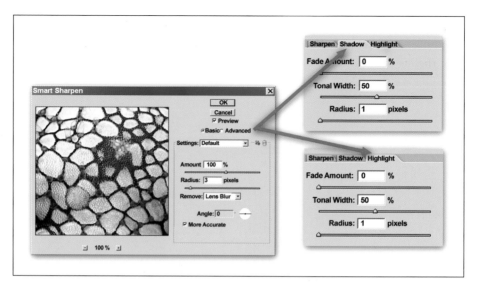

The Smart Sharpen menu features both a basic and advanced mode. Selecting the advanced mode expands into additional menus for adjusting the highlights and shadows. In most cases, use the advanced mode in the default settings, and work with the Amount and Radius controls in the main menu.

The Fade Amount slider adjusts the quantity of sharpening, and the Tonal Width controls the range of tones in the shadows and highlights. Smaller values restrict the adjustments to only the darker regions for shadow correction and only the lighter regions for highlight correction.

The Radius slider controls the size of the area around each pixel that is used in the shadows or highlights. Moving the slider to the left specifies a smaller area, and moving it to the right controls a larger area.

○ HIGH PASS FILTER

If you want maximum control of your image sharpening, you might consider using the High Pass filter. This nondestructive method allows you to change the sharpening for different types of output without destroying the sharpness of the original image.

Start by opening the Layers palette (F7), select the Background layer, and make a copy of the layer using the shortcut Ctrl/Cmd+J. Now go to Filter>Other and select the High Pass filter. Your image will look really weird, but not to worry. Move the Radius slider to about 10, and click OK. Go back to the Layers palette and sort through the blending modes at the top of the palette until you find the Hard Light mode.

You can then use the Opacity slider in the High Pass layer to control the amount of sharpness in the image. It is easy to see the anticipated results if you use the eye icon to turn the layer's visibility on and off.

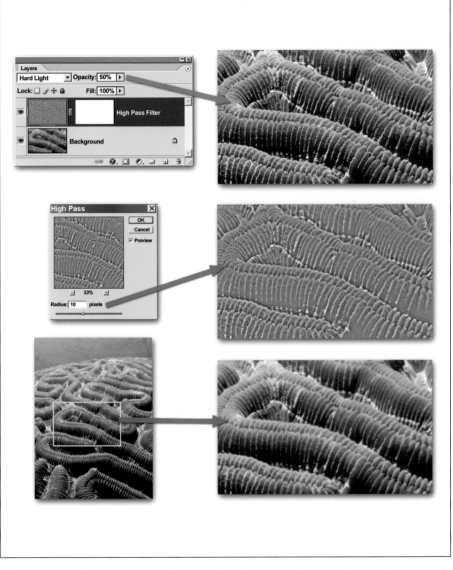

The bottom two images represent a hard coral and an enlarged section showing that it wasn't as sharp as it could have been. The middle images show the results of the Filter>Other>High Pass menu with the Radius set to 10. The top-left image shows the High Pass layer blending mode set to Hard Light and the Opacity set to 50%. The top-right image shows the result of combining the original image and the High Pass layer.

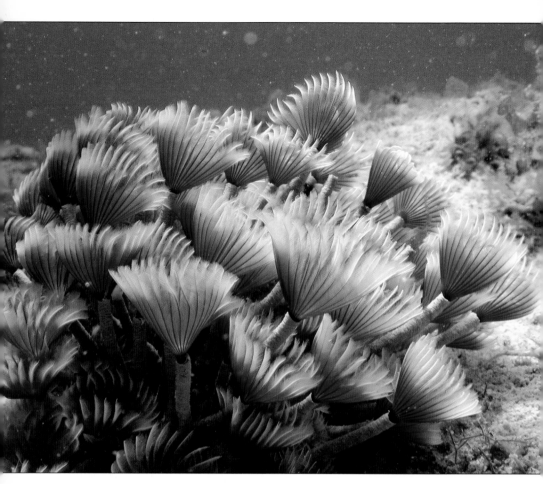

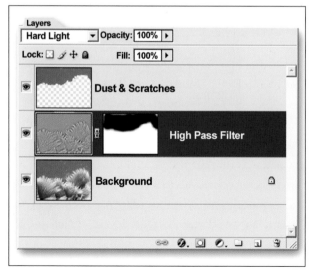

Above—*Original digital camera image of feather duster worms in the Cayman Islands.* *Left*—*The Layers menu shows the Background image at the bottom, High Pass filter in the middle, and the Dust & Scratches layer at the top.*

*Top—Enlarged section before any layer editing is added. **Center**—Enlarged section after the High Pass layer was added. Note that the backscatter in the background was unaffected by the High Pass filter because of the mask, and the resulting image is unacceptable. **Bottom**—The water background was copied and pasted as a new layer. Then the Dust & Scratches filter was applied to remove the backscatter.*

○ LAYER CONTROLS

No matter which method you use to sharpen your image—the Unsharp Mask, Smart Sharpen, High Pass filter, or maybe a third-party plug-in (see chapter 15)—you should always apply the sharpening effect to a copy (Ctrl/Cmd+J) of the Background layer. You can then use the Opacity slider to increase or decrease the effect by controlling how much the original, underlying Background layer shows through the duplicated later.

You can also use more than a dozen different blending modes on your sharpening layer. Before you scan through the different layer blending modes, make sure you have the Move tool selected from the toolbox. You can then hold the Shift key and use the + or – keys to move up and down through the layer blending modes. You can also use either the numeric keypad or the Opacity slider to change the opacity percentage.

Add a Mask. You can also add a mask to your sharpening layer, and then use the black brush to selectively remove the sharpening effect. By adjusting the opacity setting of the brush, you can control the sharpening removal. The blending mode and opacity setting for the Brush tool are found at the top of the editing screen.

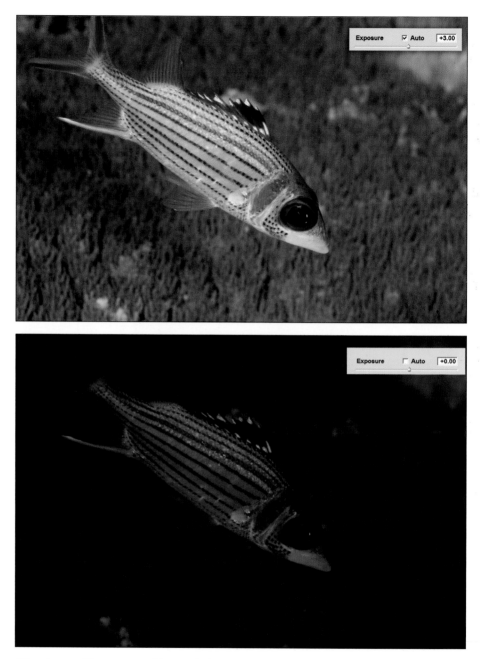

These images illustrate a problem with digital camera exposure. The top image looks good but is actually being corrected 3 stops by the RAW file editor. If you turn off the auto exposure in the RAW file editor as shown in the bottom image, you will see the actual exposure made with the camera. If you are getting these kinds of settings, you need to adjust your digital camera exposures so that the auto exposure is closer to 0.

stance, if the Auto Exposure indicates +3, you should note that your camera exposure is way off. Turn the Auto functions off initially to see just how your camera is recording the exposure. To maximize your editing capability, you must begin with a good exposure. A correct exposure should be relatively close to zero when you check the Auto boxes.

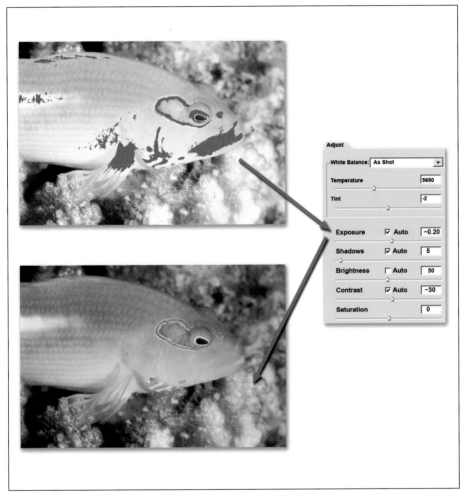

Another method for reducing blown-out areas in the RAW file image is to manually reduce the exposure. As you do, you will notice that those areas indicated in red will slowly disappear.

○ DETAIL TAB

The two most important features under the Detail tab are the Sharpness and Color Noise Reduction sliders. The Sharpness setting is pretty straightforward with one slider that adjusts the sharpness from minimum to maximum. Move

The White Balance tool was applied to a gray area on the scuba tank (top) to correct this available light image. The resulting image (above) shows a big improvement.

your cursor over the large preview image and use the Ctrl/Cmd and +/– keys to zoom in and out on the image. When you zoom in, hold down just the Ctrl/Cmd key and the cursor turns into a hand, allowing you to reposition the image. The Luminance Smoothing and Color Noise Reduction sliders are then used to reduce any artifacts that occur due to the sharpening effect.

○ LENS TAB

If you are shooting underwater images using a wide-angle lens, you may have vignetting due to light falloff. To correct this, select the Lens tab, and move the Vignetting slider labeled Amount to the right until the lighting is more even. If your image shows some chromatic aberrations (color fringing along sharp edges), you can use the sliders labeled Fix Red/Cyan Fringe and Fix Blue/Yellow Fringe to make your corrections. The Midpoint slider at the bottom of the menu is used to adjust the midpoint corrections in the upper sliders.

○ CURVE TAB

The Curve tab displays the actual photographic curve captured by the camera. If you want to adjust the ratio of tones in the shadows to highlights, you can select any of the existing points on the curve or add new ones. You can then move the selected point, and the image will reflect the changes you made to

You should check the Highlight and Shadow boxes at the top of the Camera RAW editing screen to see shadow and highlight areas that are being clipped and losing detail. In this case, a highlight was blown out, so the Curves folder was selected and the top of the curve was pulled down until the blooming disappeared.

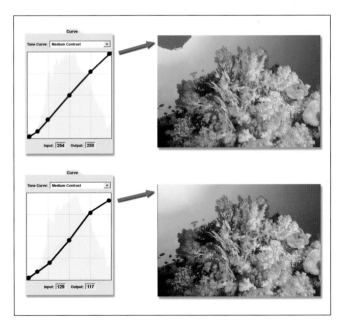

the photographic curve. A histogram of the data is displayed behind the curve to help you determine how to make your image adjustments.

○ CALIBRATE TAB

The Calibrate tab features sliders for adjusting the color settings of the camera profile used to take the RAW file. With these sliders, you can adjust the hue and saturation for the red, green, and blue channels in the image. There is also a slider that can be used to adjust the shadow tint. If you like the changes you have made, you can save them as a new profile to be used on future images. This is an extremely powerful tool for color crossover problems.

○ WORKFLOW OPTIONS

The Workflow Options menu can be found in the lower-left portion of the RAW file editor. With this menu, you can set the color management profile of the image, bit depth (8 or 16/Bits Channel), and the resolution of the image. The Size control allows you to change the actual megapixel rating of the image from less than 2 megapixels to over 25. If you know that you are going to need a larger file size for printing, this is the place to rescale the image. Also, if you know your image will need a lot of sharpening, you might consider increasing the file's megapixel rating because the higher the resolution, the more you can sharpen the image.

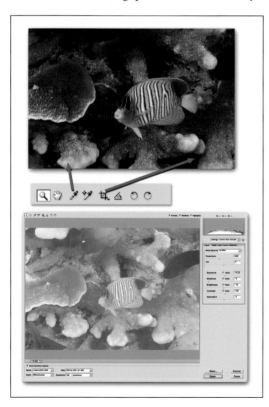

This image is extremely off color because the flash was either too weak or too far from the subject. The image was first cropped with the Crop tool in the toolbox. The White Balance tool was then used to select a small white coral in the lower-left portion of the image. The adjusted image was then imported into Photoshop for final cleanup of backscatter and other small artifacts.

This RAW file fisheye image of the Wreck of the Anne (right) in the Solomon Islands proved to be dark, bluish, and lacking color saturation. The image was easily corrected by clicking on a sandy area using the White Balance tool. No other correction was made to the image.

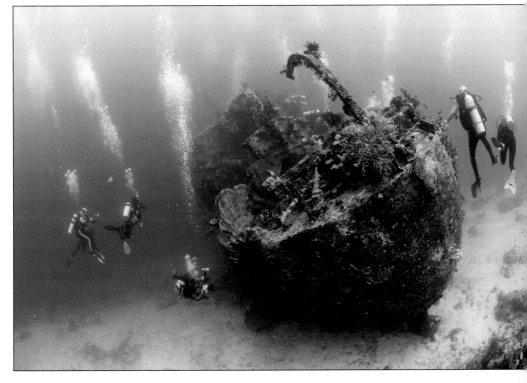

○ TOOLBOX

The RAW file toolbox is located at the top of the editor and provides powerful control over your RAW images. Working from left to right, you have the Zoom tool for zooming in and out on the image, and the Hand tool for moving around in the image.

The third icon, the White Balance tool, is probably one of the most powerful tools in the RAW editor. When you click on something that should be neu-

tral in color, the entire image rebalances. This is a fantastic tool to use on available light images. Just click on the white of an eye, an area of dead coral, or the side of a gray angelfish, and presto, you have a beautifully balanced image.

The Color Sampler tool displays the color components of a specific point you select in a RAW file image. The Crop tool works very much like the Crop tool in Photoshop, and handles on each edge of the photo can be used for resizing the image. The Straighten tool requires that you draw a line along any edge in the image that should be level. The editor will then create a new crop image that will rotate once you open the image in Photoshop or when it is saved with the RAW file. The final two icons enable you to quickly rotate the image 90 degrees counterclockwise, or 90 degrees clockwise.

○ RAW FILE LAYER EDITING

There will be times when the exposure or color balance captured by the RAW file is too extreme to bring into Photoshop. A good example of this is a split-level image where you have a good exposure above water but a dark and off-color underwater area.

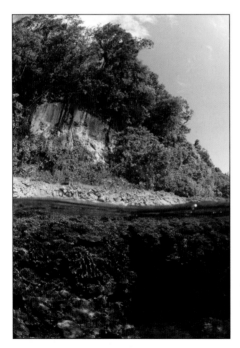

Left—This split-level fisheye image taken in the Solomon Islands has a good exposure above water but is dark below the surface. Above— The Layers palette shows the original RAW file image with good sky exposure is our background layer. The top layer is from the same RAW file, but the underwater portion has been corrected. The mask was added to block the sky in the top layer so the sky from the background could show through. Facing Page—The final split-level image was saved as a PSD file so that we could adjust the topside and underwater portions separately at a later time.

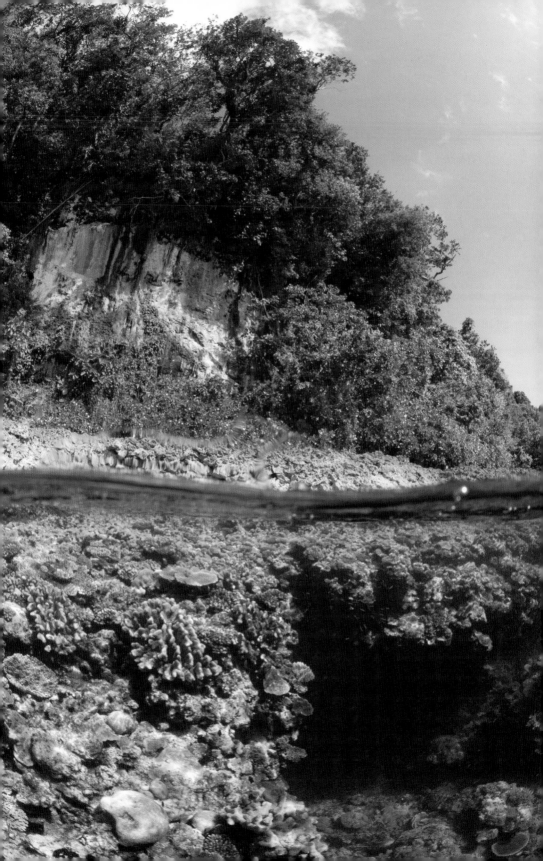

The solution is to adjust the topside portion of the image in the camera RAW editor and bring it into Photoshop as your background image. Then, reload the file and make changes with RAW file control to correct the underwater portion of the image. Open this image in Photoshop, then copy and paste it into the background image. Press the F7 key to open the Layers palette, and add a mask to the layer with the corrected underwater portion. Take the Brush tool set to black and remove the top portion of this layer so that the sky shows through.

This technique works well when you photograph an animal down in a hole. If you correct the exposure for the animal, the areas outside the hole are washed out. If you attempt the opposite correction, the animal in the hole is still in the dark. The solution is to correctly adjust each part using the RAW file editor, bring them both into Photoshop, and use the mask and brush technique to blend the two together.

If you find the mask leaves an edge between the two layers, select the mask itself in the Layers palette, and go to the Filter>Blur>Gaussian Blur, and apply this to the mask. This should fix the problem.

When you have mastered RAW file shooting and editing, you may be ready to try your hand at shooting the ultimate underwater RAW file image, a 360-degree underwater panorama. Four RAW file images were shot using a fisheye lens and were edited in Camera RAW using the same settings for all the images.

10. ADVANCED BACKSCATTER REMOVAL

One of the most difficult aspects of underwater photography is backscatter. It varies from one dive location to the next, but it is always there. Most new image editors will attempt to remove the backscatter using the Clone tool. Sure, it will work—but it is very time consuming and can often leave telltale editing signs. Here are a couple of the more advanced solutions to backscatter problems.

○ Spot Healing Brush

The Spot Healing Brush was first introduced with Elements 3 and is now part of Photoshop CS2. Unlike the Clone tool and the Healing Brush, which require a two-click process, the Spot Healing Brush requires one click to accomplish the task. Use the bracket keys ([or]) to size the brush slightly larger than the particles you want to eliminate, click on the particles, and they magically disappear.

The Spot Healing Brush is the fourth icon down on the left side of the toolbox. Brush size can be controlled by right clicking on the image, accessing the Brush menu at the top of the screen, or by using the bracket keys ([= smaller,] = larger).

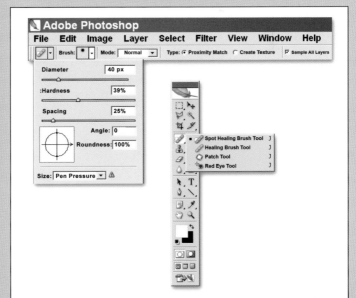

○ Dust & Scratches Filter

To remove backscatter from large areas, such as blue water or blurred backgrounds, the Dust & Scratches filter does a great job. You need to be able to clearly see the problem you are attempting to solve, so use the Zoom tool to zero in on your work area. If you find there are some really large particles, you may want to remove them first using the Clone tool, Healing Brush, or Spot Healing Brush.

Now select the Lasso tool from the toolbox and draw a line around the area in which you want to remove backscatter. Load the Dust & Scratches filter from the Filter>Noise pull-down menu, and set both the Radius and Threshold sliders to the lowest settings. Move the Radius slider to the right until all the particles disappear. The selected area will become very blurred, but that's alright at this point. Now move the Threshold slider to the right until the particles appear again, then move it slightly back to the left until they disappear once more. In the end, the particles will be gone, but the background detail remains the same. This procedure works best in out-of-focus areas, so we have a Plan B for other situations.

IF YOU FIND THERE ARE SOME REALLY LARGE PARTICLES, YOU MAY WANT TO REMOVE THEM FIRST USING THE CLONE TOOL....

Layers. A more controllable method for using the Dust & Scratches filter is to add a second copy of the background image as a layer. You can then apply the Dust & Scratches filter to the entire image and use the brush to remove the areas where you don't want the filter effect. This method is especially suited to images that have more backscatter area than subject. Here's how it works.

Open the Layers palette, then go to Layer>Duplicate Layer, and a new identical layer will be stacked on top of the Background layer. Click on the Add New Mask icon at the bottom of the palette, and a special mask will appear next to your new layer. Click on the left thumbnail image in that Adjustment Layer, and then go to the Filter>Noise>Dust & Scratches filter. Slowly move the Radius and Threshold sliders to remove the backscatter as outlined above.

When all the backscatter is gone, click on the mask in the same layer, and then select the Brush tool from the toolbox. Make sure that the foreground is set to black and the background to white. In the Brush options menu at the top of the screen, you should set the Hardness of the brush to 0%. Now brush the areas that you don't want the Dust & Scratches filter to affect.

If you need to undo some of the areas you brushed on, just swap the foreground and background colors and paint away. If you don't want the full effect

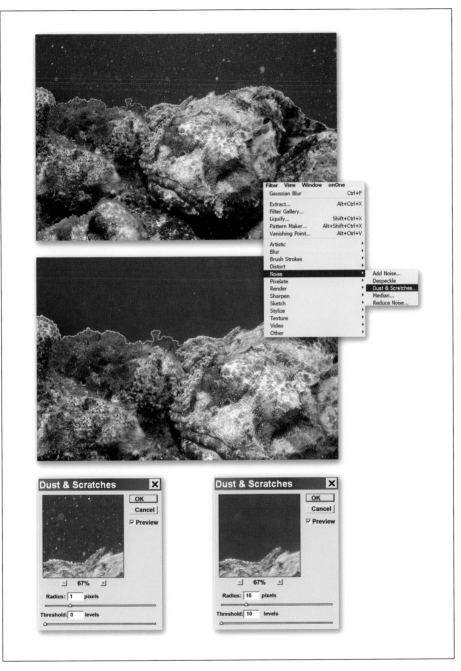

Heavy backscatter can be removed with the Filter>Noise>Dust & Scratches filter. After mini-
mizing the Radius and Threshold settings, move the Radius slider until the backscatter is gone.
Then move the Threshold slider until it reappears, and back off slightly until it disappears
again.

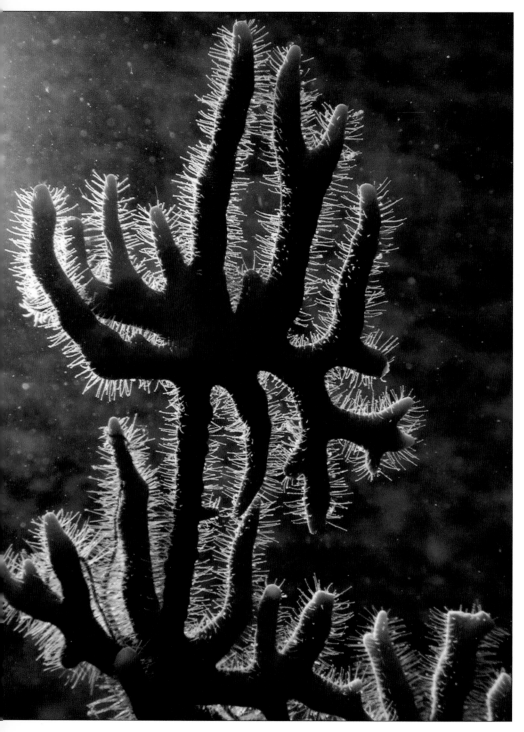

When you use a flash to light fire coral from behind, backscatter usually becomes apparent.

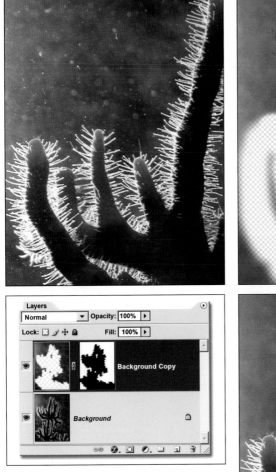

Top Left—Here's an enlarged section of the area to be fixed. *Above*—The Magic Wand and Lasso tools were used to select the background area with the backscatter problem. The shortcut Ctrl/Cmd+J was used to make a copy of the problem area. We right clicked on the New Layer thumbnail to bring up the submenu with the Select Layer Transparency command. This command loads the selection for that layer. From there you can go to the bottom of the Layers palette and add a new mask to that layer. You can then tweak the mask, using the Brush tool, set to black, to block areas you don't want the Dust & Scratches filter to affect. *Top Right*—If you want to see only your mask, click on the eye icon to turn off the layer visibility. The mask will appear as a checkerboard in the Layers palette. *Bottom Right*—Enlarged section of the fire coral after the Dust & Scratches filter was used with layering techniques.

of the filter in a specific area, you can set the Opacity to less than 100%. This will blend the effect of the Dust & Scratches filter with the background image.

A variation of this technique is to select your work area with the Lasso tool, feather your selection, and use the Ctrl/Cmd+J keyboard command to make a layer of just your selected work area. Use the Dust & Scratches filter the same way we mentioned, and your results will be the same. The difference is that you can separate each Dust & Scratches correction into its own layer, which keeps the file size smaller than making a copy of the entire background.

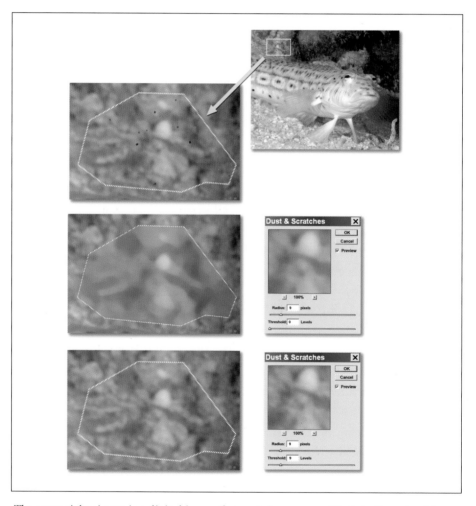

The upper-right picture is a digital image that contains sensor artifacts in the upper-left corner. The top image shows the enlarged selection around the sensor artifacts to be repaired. The middle image shows the default settings of the Dust & Scratches filter before it is applied, and the bottom image reflects the effects of the applied filter.

○ DSLR Sensor Artifacts

DSLR camera sensors can be exposed to the environment, especially when you change lenses. When this happens, small specks of dust can float down and land on the sensor, creating black particles in all of your images. In order to remove them from your photos, you should treat them as if they were backscatter. Use the Dust & Scratches filter for large out-of-focus areas, and the Spot Healing Brush for areas with fine detail.

SMALL SPECKS OF DUST CAN FLOAT DOWN AND LAND ON THE SENSOR, CREATING BLACK PARTICLES IN ALL OF YOUR IMAGES.

○ Blur Filters

When you find that you have tons of backscatter across both out-of-focus and sharp areas, you'll find that the Dust & Scratches filter just doesn't do the job. If we dig a bit deeper into our bag of tricks, we find two types of blur filters in the Filter>Blur menu that will allow you to slightly blur small particles and still maintain image detail.

Smart Blur. You need to be aware that if there is much backscatter across your image, you'll have to sacrifice a bit of overall sharpness in the correction process. The Smart Blur filter was introduced with Photoshop CS, and it can selectively blur different levels of detail in an image. Unfortunately, it is not an easy filter to use, as it reacts quite differently with each image and its unique problems.

The easiest way to use this filter is to start by zooming in on an area that has both out-of-focus and sharp detail. Then set the Radius to 20 and the Quality to high. The Radius determines the edge size of the blurred areas. Set the Threshold from 5–40 depending on the severity of the problem. The Threshold setting determines what qualifies as an area to blur. The higher the Threshold number the less visible the backscatter, but the more blurred the image detail.

For better control when using this filter, make a copy of the image in the Layers palette and add a mask. Apply the Smart Blur to the duplicate image, and then use the black brush on the mask to eliminate any unwanted detail.

Surface Blur. A new backscatter solution called Surface Blur became available with the introduction of Photoshop CS2. When you open the Filter>Blur>Surface Blur filter you will immediately notice that it resembles the Dust & Scratches filter, but its application is quite different.

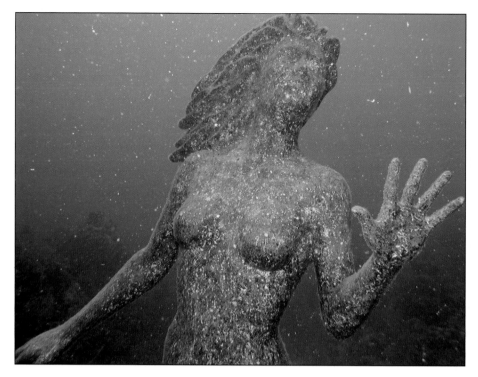

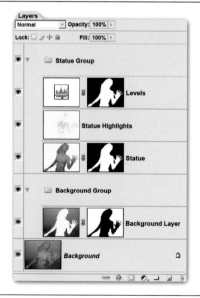

Above—Although the water visibility was poor, we took this image anyway using one of the first digital underwater cameras. *Left*—This image required some complex corrections, so we grouped our changes into two sections. The original image is shown as the Background layer. The Select>Color Range command was used to select the water in the background. The shortcut Ctrl+J was used to create a new layer and a mask was added. The Filter>Blur>Smart Blur filter was then applied to that layer.

The selection was then loaded from the thumbnail, inversed, and turned into a second layer with the Ctrl+J command. A new Select>Color Range selection was made that only included the light areas on the statue. A new layer was made from this selection, and the Filter>Noise>Dust & Scratches filter was applied. Finally, a new Levels Adjustment Layer was added to the statue group of layers where we adjusted for correct color, brightness, and gamma levels.

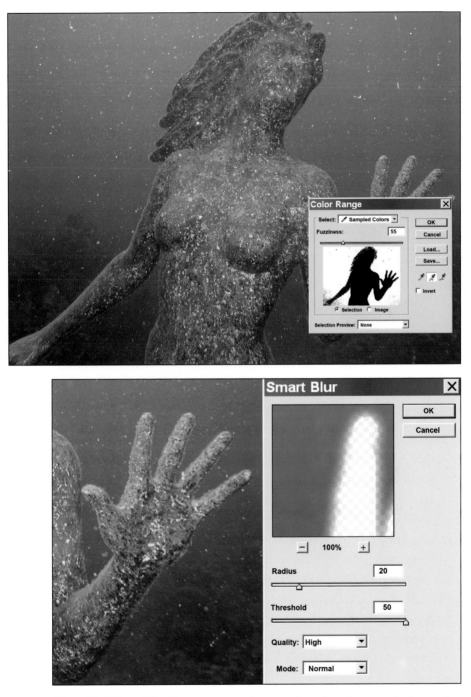

Top—*The Select>Color Range command was used to select the water background so that a new layer could be created from that selection.* ***Above***—*The Filter>Blur>Smart Blur filter was applied to this new layer.*

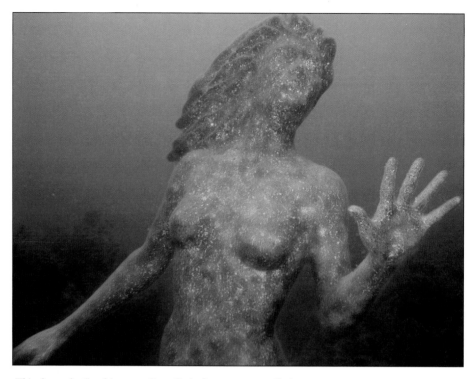

This shows the final image after all the layers were applied.

Move the Radius slider to a fairly high number, say 25–50, and then slowly increase the Threshold until you have sharp subject detail while still keeping the backscatter at bay. Every image is different, so the settings for the Radius and Threshold will vary. The best bet is to experiment, and use the Preview box to minimize the detail loss as you eliminate the backscatter. You will find that this process will slightly blur the image, so we highly recommend that you use the Unsharp Mask to help restore any lost image sharpness.

As you work your way through this process, you may find that a few of the small particles have now become dominant. Cleaning up the image is a simple process of using the Dust & Scratches filter on the out-of-focus spots and the Spot Healing Brush on the detailed areas.

An additional benefit to this filter is that while removing backscatter, the filter also reduces noise in the background, and it doesn't matter whether it was the result of film grain or digital camera noise! If you find that the digital noise has been reduced too much, you might consider using the Add Noise filter to introduce small amounts of noise to equalize the editing effect.

Top—*This digital camera image taken in the Solomon Islands has both large and small backscatter particles. The Spot Healing Brush was used to remove the large particles.* **Bottom**—*The Polygonal Lasso tool was used to select the backscatter in the background before the Filter>Blur>Surface Blur filter was applied to the selection.*

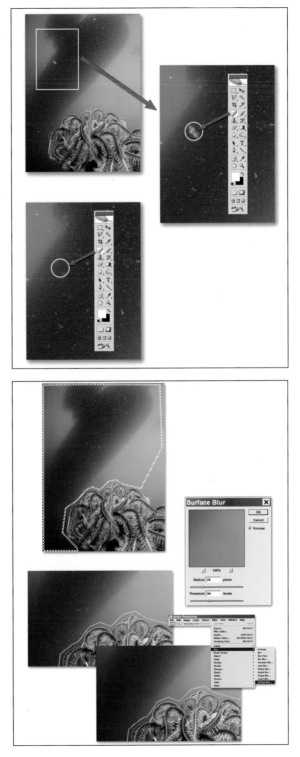

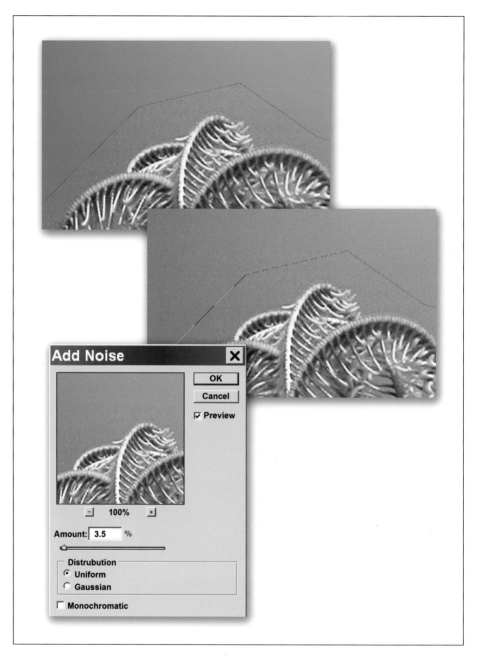

When you enlarge a section where the Surface Blur filter was used, you will notice that it is much smoother than the unedited section. To equalize both sides, go to the Filter>Noise>Add Noise command and move the slider until the background noise in the selected and unselected areas match.

11. REMOVING UNWANTED OBJECTS

A s your editing skills improve, you will be anxious to tackle more complicated problems. Be aware that the editing problems often increase exponentially with the size of the area you need to edit!

Decades ago when underwater photographers were struggling with new film technologies, divers weren't as reef conscious as they are today. Divers made direct contact with the reef, touching, feeling, and dragging gauges along the way. Those times have since gone by the wayside, as we now work to put reef survival before our passion for underwater photography.

This presents a dilemma. Film images can last more than 50 years and often contain great content that may not easily be replicated. Do we use these photos as they are, or do we make them politically correct in Photoshop? In our first book we suggested adding a circle around the letter M (similar to the copyright symbol) to indicate image manipulation. No matter how you address the issue of ethics and image manipulation, we feel that there are many outstanding images that could use a helping hand. Let's see how Photoshop can help us correct our past mistakes.

FILM IMAGES CAN LAST MORE THAN 50 YEARS AND OFTEN CONTAIN GREAT CONTENT THAT MAY NOT EASILY BE REPLICATED.

O HANGING GAUGES

One of the most common problems with older images of divers is that their dive gauges hang down and touch the reef. Removing the gauges with Photoshop cleans up the photo and allows the viewer to assume that the gauges are safely tucked away. Removing gauges is a pretty straightforward process, and the technique can be applied to a wide variety of equipment problems you may encounter.

The first step is to isolate the problem area using the Lasso or Polygonal Lasso tool. By selecting this area, you are protecting the remainder of the image from the effects of your editing. In many cases, the areas you need to edit are very close to the reef or diver, so this preselection is critical.

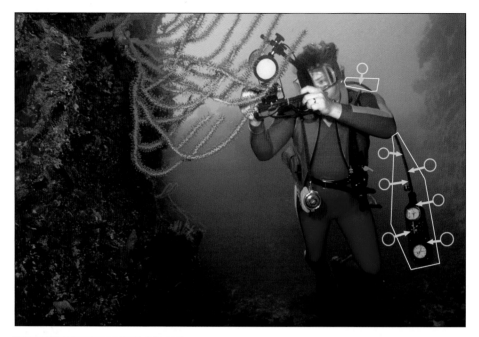

Above—This film image shows the diver with gauges that are not secured. We selected the area to be removed with the Polygonal Lasso tool. This protected the rest of the image while the Clone tool was used to replace the gauge area with water. Left—The Clone tool and Healing Brush are found in the toolbox. The tools' options include shape and size, mode, source, and alignment.

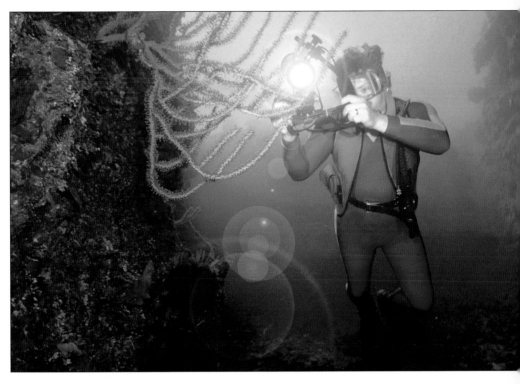

This is the final image after both the Clone tool and Healing Brush were used to remove the hanging gauges and spare regulator. The Filter>Render>Lens Flare menu was used to add light to the flash.

Once you have made your selection, zoom in so you can better see your editing area. Be sure to add some extra space around the vicinity of your selection, as you may need it for capturing additional data when cloning or using the healing tools. Select the Clone tool and slowly copy the areas adjacent to the gauge onto the gauge until it entirely disappears. You may discover to your dismay that you can see areas where you edited, so you must perform another step in order to cover your tracks.

Select the Healing Brush from the toolbox, and go over the same area that you initially cloned out. This should cover up any areas that became visible when using the Clone tool. If there are considerable changes in tonal values, you will probably need to set the Clone tool's opacity level (at the top of the editing screen) to 50–60% so that it takes more passes, resulting in a smoother application.

Removing or reducing divers' air bubbles uses the same process except that you may have to set the opacity even lower (30–50%) to hide your editing. In

most cases, the bulk of the bubbles are acceptable, but occasionally a few extraneous bubbles detract. When this happens, the Spot Healing Brush is the tool of choice for removing individual air bubbles. This process can also be used when you have a couple of small, dark fish silhouettes that draw viewers' eyes away from the main subject.

○ HEALING CORAL

We really wish that the next process we are going to show you could happen in reality, but unfortunately dying coral is becoming part of our legacy. These patches of dead reef, often due to coral bleaching, become very evident when you take wide-angle images. You have several choices about how to deal with the problem. You can swim past and opt not to take the image, show it as is, or repair it. The first two choices are easy; the third option is a bit more difficult.

Use the Magic Wand. Your first step is to select the area to be repaired. In most cases, the dead coral area will be light toned, so the best tool for the job is the Magic Wand. Click on the area and see how much the tool selects. If your selection goes beyond the dead coral area, then you should set the Tolerance to a lower number. If you have selected about half the area, your Tolerance setting is about right. If you still need to add to your selection, either hold down the Shift key or select the Add to Selection icon from the upper-left corner of the main editing screen.

IN MOST CASES, THE DEAD CORAL AREA WILL BE LIGHT TONED, SO THE BEST TOOL FOR THE JOB IS THE MAGIC WAND.

Clone Tool. Once you have your selection, you should go to the Select>Feather command and set the Feather Radius at 1–3 pixels depending on the size of the selection; the bigger the image area, the larger the Feather Radius you should set. Grab the Clone tool from the toolbox, and start to clone from areas near the dead coral. Look for selection material that contains the density and texture of the live areas. Your results may not look perfect, but that's okay as this cloning step is used to build up a base density just like a painter does on a canvas.

Healing Brush. To cover up the imperfections of the Clone tool editing, you will want to switch to the Healing Brush and repeat the process. This second pass should give you a nice texture and tonal value that looks very natural.

If you don't like the idea of switching back and forth between the Clone and Healing Brush, set the Mode (top of the editing screen) for the Healing Brush

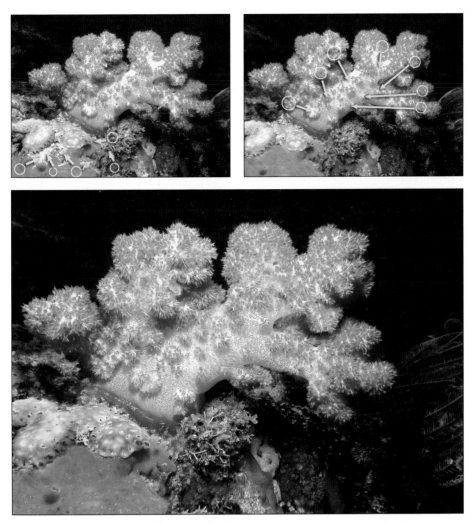

Top Left—This digital camera image of Fijian soft coral has blown-out highlights and several patches of dead coral and sponge. The Clone tool was used to copy data from the sponge and fill in the light areas. *Top Right—The Healing Brush was then used to place new data onto the bright areas on the soft coral.* *Above—The Spot Healing Brush was used to remove any remaining backscatter.*

to Replace, and it will work just like the Clone tool. Once you have made your first pass, you can switch it back to the Normal mode to get the Healing Brush effect. Before you save the file, zoom in on the edges of the edited area to see if there are any small imperfections between the edited and nonedited areas. If there are still some slight imperfections, reduce the size of the Healing Brush and slowly work your way around the edge of the edit area. You might even try

the new Spot Healing Brush as it also does a great job covering up small editing errors.

○ NONDESTRUCTIVE REPAIRS

In all the previous examples, we have shown you how to repair sections of images by working directly on the background image. If you want to have the ability to modify your editing later, you need to work in the nondestructive mode. Once you select the area you wish to repair, use the Ctrl/Cmd+J shortcut to create a new layer containing just your selected repair area. You can then continue working on your new layer using the techniques we previously mentioned.

If at any time you want to reduce or remove the effect, add a mask to your layer and use the black brush. Be sure to set the opacity level to selectively remove the editing from a specific area (50% removes half the editing, 25% removes a quarter, and so on). The smaller the opacity setting, the more control you have over removing your editing efforts. Make sure that the Sample All Layers box at the top of the editing screen is checked when working with the layers.

○ COPY DATA FROM ONE PHOTO TO ANOTHER

There will be times when the image to be healed has no texture that can be copied into the repair area. In this case, you might consider selecting your needed texture and data from a totally different photo. Obviously, it needs to be a similar photo—maybe the image you shot before or after the image you

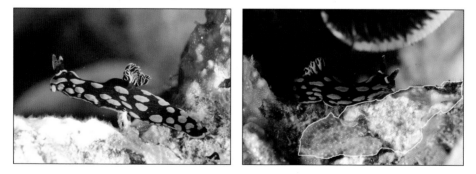

Left—This nudibranch was photographed on Velvia Reef in the Solomon Islands. The light-colored foreground, position of the flash, and the reflectiveness of the nudibranch caused an overexposure in the foreground. Right—A selection was made from a similar image with correctly exposed reef detail.

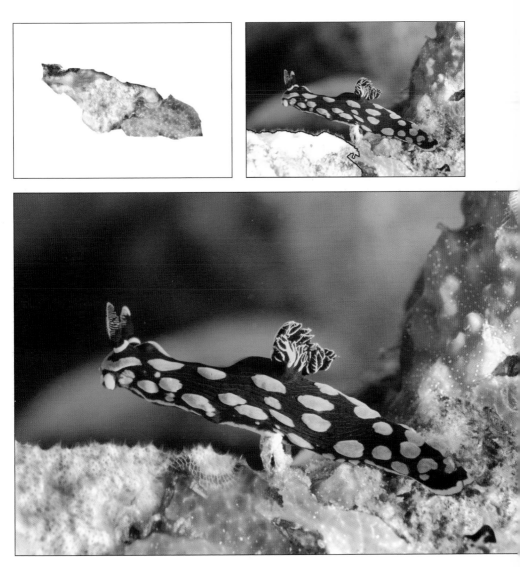

Top Left—*The copied data is pasted onto a blank image, flipped, and rotated before it is copied again to the clipboard.* *Top Right*—*A selection is made on the image to be repaired. The selection is feathered by 2 pixels.* *Above*—*The shortcut command Shift+Ctrl+V is used to paste the selection stored in the clipboard into the area. You can also paste into a selection by using the Edit>Paste Into command from the pull-down menus.*

are working on. Select the needed texture and copy it to the clipboard. There are a couple of ways to attempt this data transplant.

Make sure that the Sample All Layers box is checked at the top of the editing screen when trying either method. For the first method, paste the data into

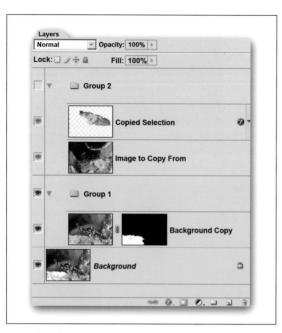

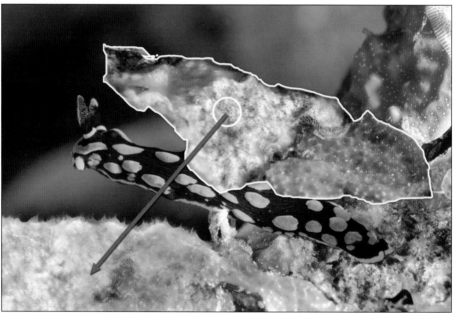

Top—A second method for correcting this image uses advanced layer techniques. The first group is a copy of the Background image and a mask. The second group is the image where the data is copied from, and the copied selection as a layer. The Clone tool was used to copy data from Group 2 onto the image in Group 1. Above—The Clone tool was used to select data from group 2 that is shown outlined in white.

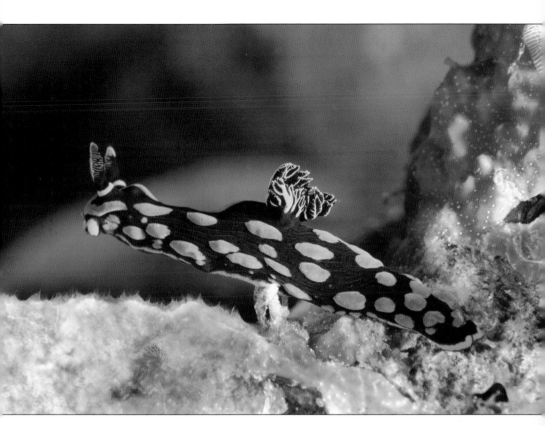

This image shows the final effects of using the Clone tool sampling from a second image.

your selected repair area and you can scale, transform, blend, and adjust the opacity until it looks just right.

For the second option, you would paste the data next to your selected repair area, and this pasted data will appear as a new layer. Use the F7 key to open the Layers palette and select the background image. Begin your Clone or Healing Brush process using the pasted layer as your data source. Once you have completed your efforts, turn the eye icon off for this layer to remove it from view.

○ PLUG-IN FILTERS
More solutions for filling in large dead areas are covered in chapter 15—a chapter devoted to third-party plug-in filters for underwater photographers. The main plug-in of interest, the Smart Fill, is part of the Image Doctor series from Alien Skin (www.alienskin.com).

12. DIVER MODIFICATIONS

Photographing other divers, especially photographers, presents several problems like depth perception, lighting, and equipment issues. In most cases, it's just a small reflection, bright object, or lines and shapes that detract from the main image content. Occasionally the diver's equipment may appear amiss due to the angle at which the image was taken. Let's see what solutions Photoshop offers for correcting these problems.

○ FLASH ANGLE

When photographing other underwater photographers you may find it difficult to communicate your directions. Your attempt to direct the model may result in the flash being misaligned with the subject in the foreground. Not to worry as we can fix that problem in a flash! (Sorry, we couldn't resist.)

The fastest and most efficient repair option is to use the Polygonal Lasso tool to select the flash away from the background. Then go to Layer>New> Layer via Copy or Ctrl/Cmd+J to create a new layer containing just the flash. Press Ctrl/Cmd+T to activate the Transform function, and rotate the flash into the correct position. The rotate icons will be located outside the transform area and are indicated by a double-headed curve.

This is a scanned film image of a diver shooting with an SLR camera and flash in Fiji. Note that the flash in the picture did not fire, and it appears to be pointed at a slight angle away from the subject.

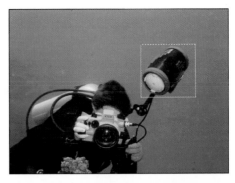

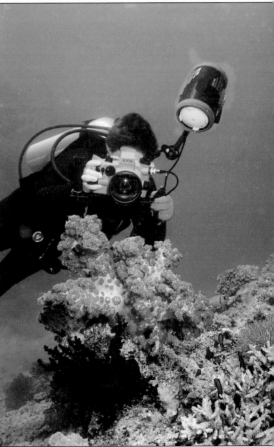

Top Left—*The Polygonal Lasso tool was used to select the flash, and the selection was copied to a new layer via the Ctrl/Cmd+J shortcut.* *Top Right*—*The shortcut Ctrl/Cmd+T was used to create an image Transform to the new layer.* *Bottom Left*—*When you right click on the Transform selection, a list appears offering several choices. We selected the Rotate function, and the layer was rotated until the flash correctly lined up with the soft coral subject.* *Bottom Right*—*The Layer>Merge Down function was applied to the flash layer so that the Clone tool and Healing Brush could be used to fine-tune the new flash angle.*

Once the flash angle has been corrected, you can select the flash layer with the mouse and move it into the correct position so that it aligns with the flash arm. Select the Background layer from the Layers palette and use the Clone tool to remove any duplication of the flash in the background. The cord may no longer align with the flash, so you may have to copy and paste a section of

Left—The soft coral was selected with the Select>Color Range command so that a reverse selection would select everything else. Right—The bottom layer is the original image without corrections. A copy was created with the Ctrl/Cmd+J shortcut and modified so that the flash angle was correct. The Select>Color Range menu was accessed to select the soft coral, and Inverse Selection was used to select the background. A new Brightness/Contrast Adjustment Layer was added, and the brightness and contrast were reduced to subdue everything but the soft coral. Finally, a new layer and mask were added to the top of the stack. The mask was filled with a radial gradient fill from white to black. The layer was then selected and a Filter>Render>Lens Flare effect was applied to the flash head.

the cord and rejoin it with the flash. Any final editing with the Clone tool may require that you flatten the image.

Add a Flash. Now that the flash is positioned correctly, you may find that it did not fire, so you might consider adding a small amount of light with the Filter>Render>Lens Flare command. Even though this command was designed to simulate lens flare, it also works well when you want to create the appearance of a very bright flash source.

You can position the flare and the brightness of the flash so that it looks like the flash really fired. If you have trouble positioning the flare over the flash, you might consider putting the flare on its own layer by going to Layer>New Layer. Fill the layer with black (Edit>Fill>Black) and select the Screen blending mode from the top of the Layers palette. Once the lens flare is applied to the new

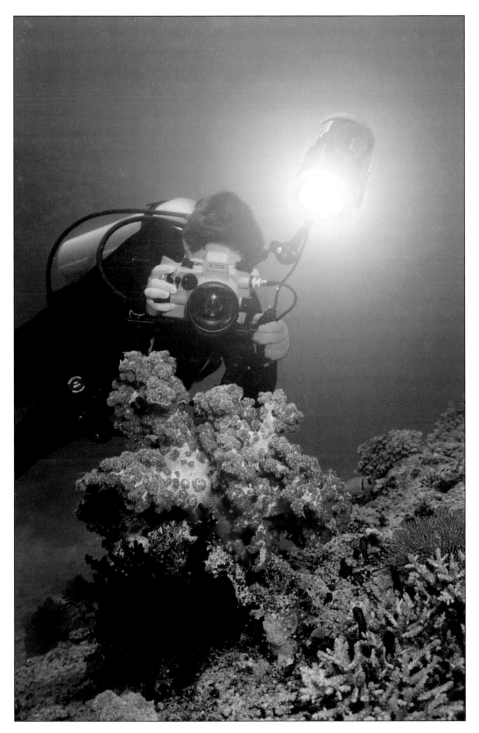

This final image shows corrections to the flash, as well as brightness and contrast adjustments.

layer, it is easy to move the layer to correctly fit over the flash head. You can then use the opacity setting to change the brightness of the lens flare you created.

○ SNAPS, GAUGES, AND METERS

There will be times when a diver's form looks cluttered with all the safety gizmos they wear underwater. Removing the extraneous equipment doesn't necessarily make them look unsafe, but rather creates a more pleasing photo. The best tools for these tasks are the Clone tool, Healing Brush, and Spot Healing Brush. If the object is very small but bright, the Spot Healing Brush will do a great job. Just touch the Spot Healing Brush over the offending area, and it will disappear.

The Clone tool is great for covering up larger light-colored objects on dark backgrounds. Select the dark areas next to the light-colored object, click with the Alt/Opt key held down, release the Alt/Opt key, and click again on the light-colored object.

Finally, the Healing Brush is best suited for removing light-colored objects on darker-colored backgrounds. Use this tool just as you would use the Clone tool (discussed above), and it will match the brightness value of the area you are covering. You may have to apply this tool several times to the same area to reduce the overall brightness of the area you are trying to hide.

THERE WILL BE TIMES WHEN A DIVER'S FORM LOOKS CLUTTERED WITH ALL THE SAFETY GIZMOS THEY WEAR UNDERWATER.

○ FACE MASKS

Another set of unique problems results when photographing divers' face masks. The flash reflects off the mask or bounces off at an angle, leaving a dark shadow on the diver's face. One problem deals with too much exposure, and the other with too little, so each problem must be treated differently during the repair process.

Generally, the Burn and Dodge tools will not solve the problem, as the exposure variations are generally too extreme. In most cases, you will end up covering up the problems with new data. Here's how we use Photoshop to repair these two problems.

Reflections. The best way to solve this problem is to copy data from one side of the mask to the other. To accomplish this complex task, you must first

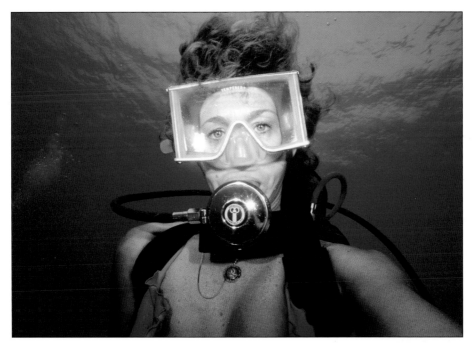

*Above—This female diver has reflections on her facemask and regulator. **Right**—The right eye and mask were selected using the Elliptical Marquee tool. The selection was copied to the clipboard and feathered 2 pixels.*

zoom in on the mask with the Zoom tool, or the Ctrl/Cmd + and –, and use the Spacebar with the Hand tool to center the area to edit on the screen. Next, use the Lasso tool to select a similar portion of the mask that may be used to replace the bad section. Feather your selection slightly, say 1–2 pixels. Copy the selection using Ctrl/Cmd+C, then paste it back into the image with Ctrl/Cmd+V. If you need even more control, you can copy your selection to a layer as before.

In most cases, your pasted selection will be backwards, so you can use the Ctrl/Cmd+T key to bring up the Transform function. Then just right click, flip your selection, and move, size, rotate, and position the layer over the area to be repaired. If you find that you copied and pasted too much data, select the layer and use the eraser to remove the unwanted data. You can also use the blending modes or the opacity setting at the top of the Layers palette to change how the new layer blends with the background image.

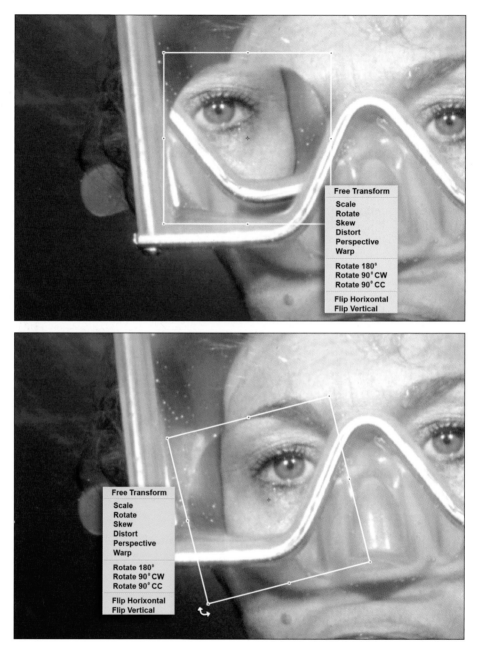

Top—*An area on left side of the facemask was selected and feathered by 2 pixels. The copied right eye selection was pasted with the Edit>Paste Into command. The Ctrl/Cmd+T command was then used to create the Transform marquee around the new layer. Right clicking on the Transform command provides a list of options.* ***Above***—*The pasted selection was then flipped, sized, and rotated until it fit perfectly on the left side of the face.*

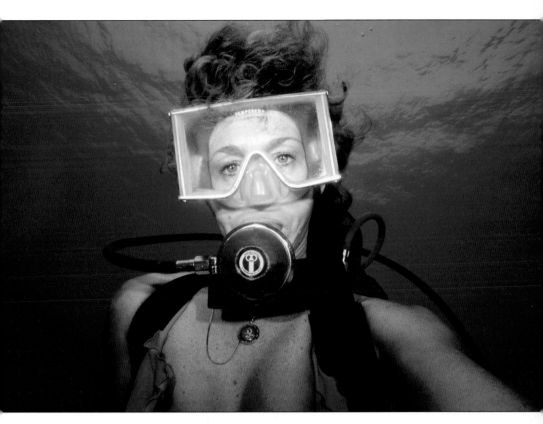

The same procedure was used to remove the reflections from the regulator.

When you find that the reflections are too great, you can copy and paste a mask from a shot taken on the same dive or a similar dive and paste it onto the problem image. Again, you can transform the selection to fit the new edited area, then use the blending and opacity functions to add the finishing touches.

Shadowed Face. In this scenario, you will need a second photo to replace the dark face inside the mask. Your first task is to select the area inside the mask you are trying to repair. If the area is very clear cut, you might be able to use the Magic Wand to select the area. If not, try the Polygonal Lasso tool and manually select the area. Make sure you feather the selected area by 1–3 pixels, depending on the size of the mask (1=small, 2=medium, 3=large). Then save your selection using the Selection>Save Selection command.

Find a second photo of the same diver that has a good exposure and, if possible, the same camera angle. Using the Magic Wand or the Polygonal Lasso tool, select all the areas inside the mask that you think you'll need. Go to Select>Modify>Expand and add 2–3 pixels to the selection. Use Ctrl/Cmd+C

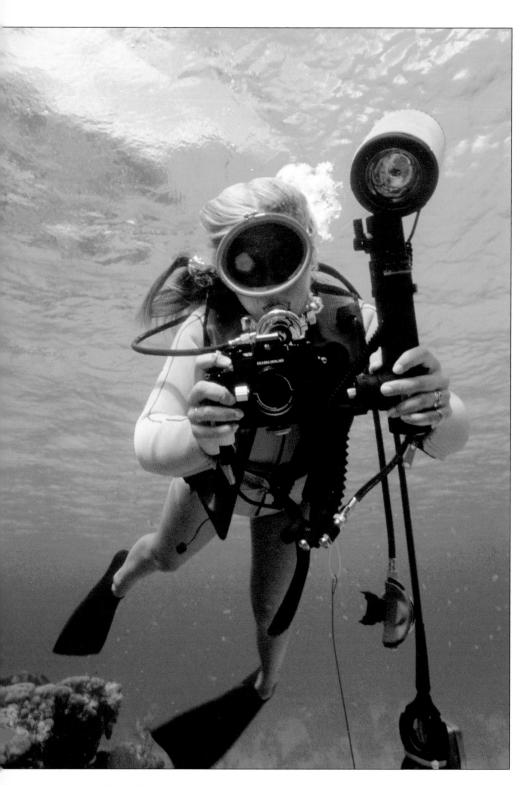

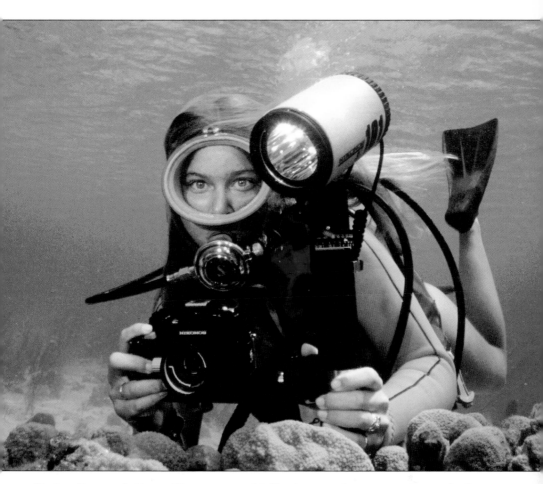

Facing Page and Above—*These are two old film images taken many years ago in San Salvador, Bahamas. One image has good lighting on the diver's face, the other does not. This is a case where two wrongs just might make one right.*

to copy the image, and then change back to the image you are repairing. Paste the copy area into the selection with the Shift+Ctrl/Cmd+V keystroke combination, and initiate the Transform function with the Ctrl/Cmd+T command. You can then scale, rotate, and position the new face inside the problem face mask. Again, if you find that you don't want sections of the pasted layer to show, you can select the layer and use the Eraser tool to remove any offending parts.

Because the face is copied from another photo, the newly pasted area may not exactly match the repaired image, and your work may be obvious. Most of the mismatch problems can be corrected using the Levels editor and Ctrl/

Cmd+U to activate the Hue/Saturation command. Be sure to save this file with an L after the name (e.g., FileNameL.psd) before saving the final file (FileNameF.psd). You may discover at a later date that your edited file has some flaws. This allows you to load the layered image and continue editing.

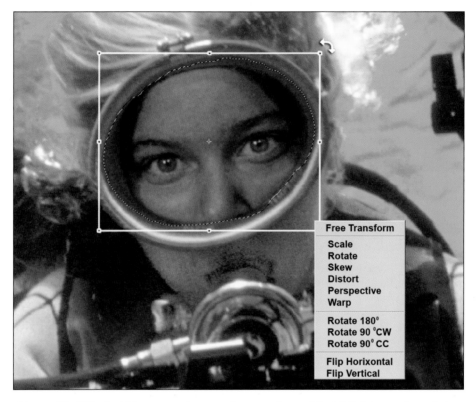

*Above—The Elliptical Marquee tool was used to copy the good facial lighting and put it into the other image. The Ctrl/Cmd+T keys were used to access the Transform command to size and rotate the new layer. **Facing Page**—Note that we also used techniques discussed in chapter 11 to remove the unsightly gauges in this final image.*

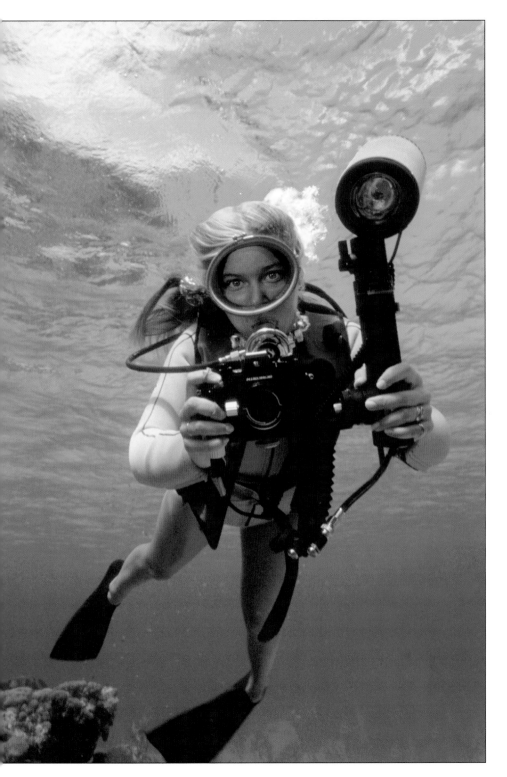

13. EDITING BLOOMING EFFECTS

W hen taking a digital camera underwater, one of the common flaws photographers encounter is an exposure problem called blooming. Blooming occurs when the light level exceeds what the sensor chip inside the camera can record. The smaller the chip, the greater the blooming effect, so a DSLR has less blooming than a digital point & shoot camera.

There are few shooting techniques you can use to avoid or eliminate this problem, but what can you do to salvage images that already suffer from the blooming effect? There are more than a half a dozen Photoshop solutions to this problem, but we offer two that we feel work well. In this chapter, we'll concentrate on both images that have blooming in open water and those with the pure-white hole positioned behind a subject, as the tools used in each situation are quite different.

○ BLOOMING EFFECT IN OPEN WATER
Make Your Selection. When working on an image with the blooming effect in open water, the first step is to zoom in on the blooming area and press the Spacebar (this brings up the Hand/Move tool) and click and drag using your mouse to center the problem area on the screen. Next, select the Elliptical marquee tool and place your cursor in the center of the blooming effect. Hold down the Alt/Opt key and drag the cursor out until the selection covers the entire blooming area, plus a little bit extra for blending.

ONE OF THE COMMON FLAWS PHOTOGRAPHERS ENCOUNTER IS AN EXPOSURE PROBLEM CALLED BLOOMING.

If you are having trouble getting the selection right, don't worry, just get it close. Then go to Select>Transform Selection and use the handles to size, rotate, and position your selection over the blooming effect.

If the blooming effect has very sharp edges, you could also use the Magic Wand to make your selection, and then go to Select>Modify>Expand to increase your selection by 10–20 pixels. Next, go to Select>Feather and set the

Top—*This digital camera image of a trumpet fish taken in Bonaire shows the blooming effect.* *Center*—*The Elliptical Marquee tool was used to create a circular selection around the blooming area. The selection was feathered (Select>Feather>55) to ensure a smooth blend from the layer to the background.* *Bottom*—*The selection was copied to a layer via the Ctrl/Cmd+J command. Right clicking on the thumbnail displays the Select Layer Transparency command, which reselects the area. A new mask was added to the layer by clicking on the Add Layer Mask icon.*

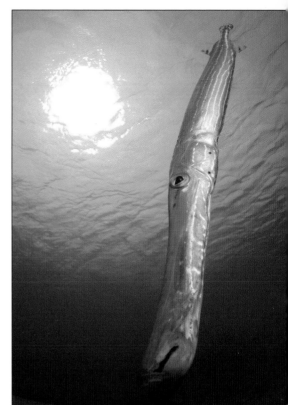

Feather Radius to 25–55 (experiment for effect) so that your selection will blend into the background.

Create a Layer. Copy the selection to the clipboard and use the Edit> Paste Into command to create a special blooming editing layer. The selection marquee may disappear when the layer is pasted, so go to Select>Load Selection to reload the marquee. A faster way to create a layer from your selection is to use the shortcut command Ctrl/Cmd+J (Layer via Copy).

Set the Foreground and Background. Click on the foreground color box in the toolbox and touch the Eyedropper tool to the middle of the blooming effect, which should be white. Set the background color by clicking on the background color box; take the Eyedropper and touch a color at the edge of the circle selection about halfway up.

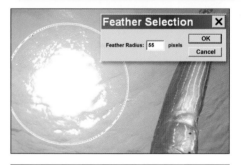

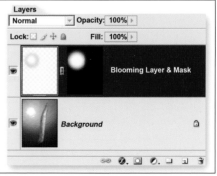

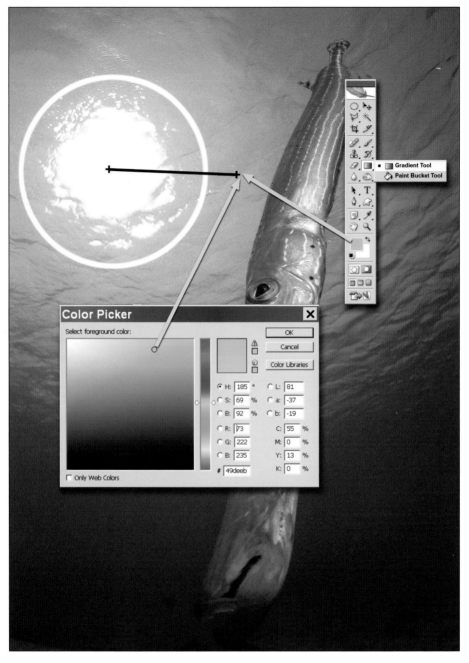

The foreground color was set by clicking on a bluish color outside the selection, and the background was set by clicking on the center of the blooming effect. The Gradient tool was then selected and drawn from the center of the blooming effect to the same point used for the foreground color selection.

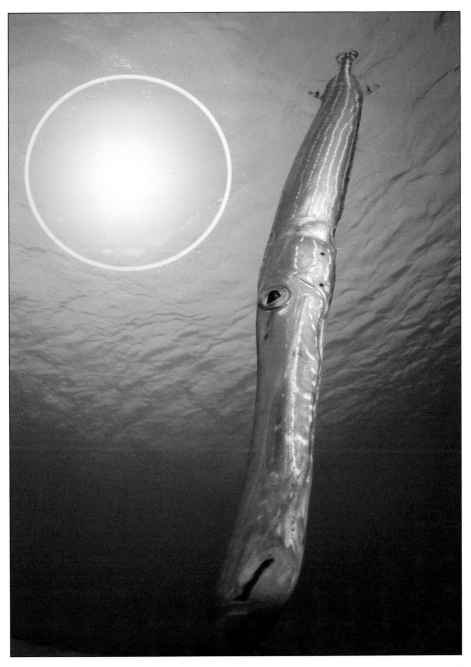

The image should now have a smooth transition from the center of the blooming effect to beyond the selection.

Gradient Tool. Select the Gradient tool from the toolbox, and drag the fill from the center of the selection to slightly beyond the edge. If the mix at the edge of the selection looks off, try applying the gradient from the center to only about halfway out. You can tweak this blending effect between the blooming layer and the background by opening the Layers palette (F7) and selecting

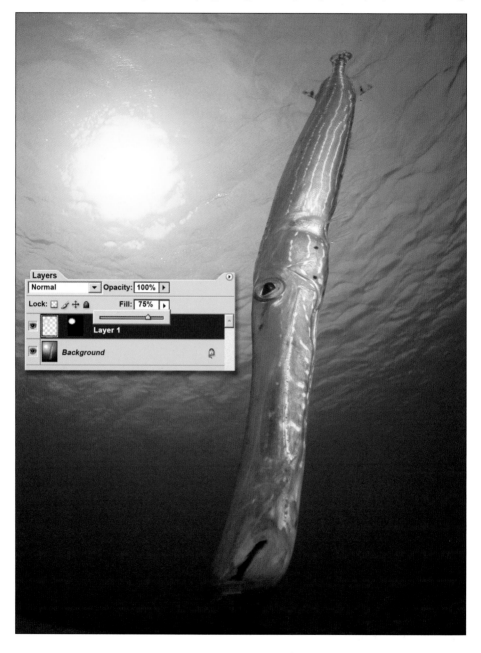

the Opacity setting that produces the right mix. If you find the layer looks too smooth, then you can go to Filter>Noise>Add Noise and increase the noise so that it better matches the surrounding area.

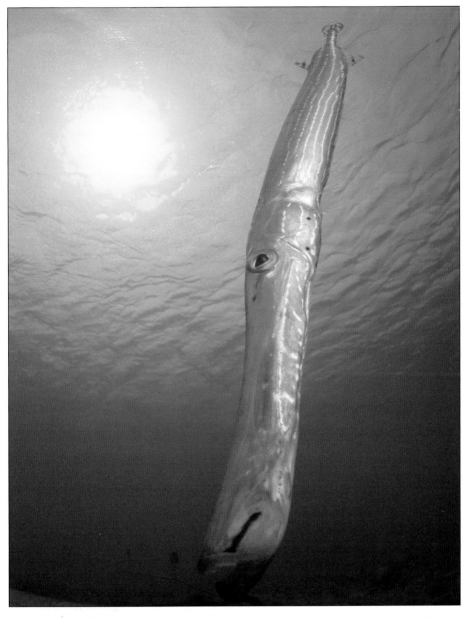

Facing Page and Above—The Gradient Fill can often create too smooth a transition. You can go to the Layers palette and adjust the Opacity setting to blend the layer and background until the effect looks more natural.

Blur Filters. A second solution for open water blooming involves the Filter>Blur options. Before trying any of the Blur filters, make your selection using the Magic Wand, and go to Select>Modify>Expand to increase your

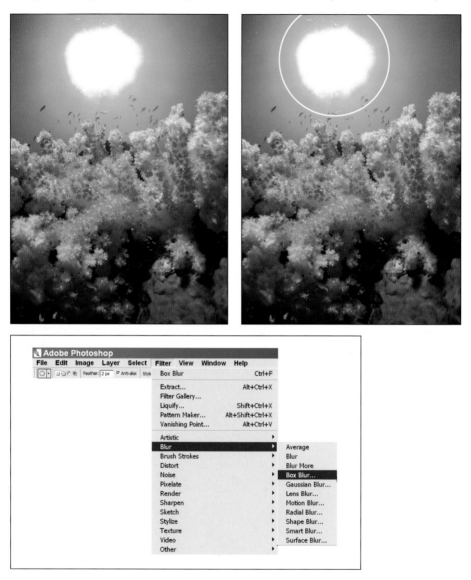

Top Left—*This image of Fijian soft coral shows the strong blooming effect created by shooting directly into the sun. **Top Right**—The first step in reducing the problem is to use the Elliptical Marquee tool to select an area around the blooming effect. **Above**—A quick fix without using layers is to go to Filter>Blur>Box Blur and apply this filter directly to the selected blooming area. The Radius slider in the Box Blur menu increases or decreases the effectiveness of the repair.*

selection area by at least 15 pixels. Go to Select>Feather and set the Feather Radius to 25–35 pixels to ensure a good blend. Work your way through the different Blur filters until you find one that works well.

The final repair with the Box Blur filter provides smooth edges where the blooming effect joins the water that surrounds it.

The Box Blur is new to Photoshop CS2 and features a single Radius slider that allows you to choose a setting of 0–999 pixels, although, in most cases, 0–100 will give you the best blurring effects. The Gaussian Blur function has a slider that allows you to choose a setting of 0–250 pixels, but you should achieve your best results from 0–80. The Shape Blur is also new to CS2 and allows you to pick a wide variety of shapes to distort the blur. Its slider scale runs from 0–1000 pixels, but the best results are found in the 20–80 range.

Healing Brush. Photoshop CS2 users have another problem-solving option with the Spot Healing Brush. Set the brush size to about 15–20% larger than the blooming effect and click in the middle. The brush will then fill the blooming effect much like we showed you at the beginning of this chapter. There may still be some visible editing effects, but you can cover them by deselecting the corrected blooming and going to Filter>Render>Lens Flare and applying a lens flare to the center of your edited bloom. This filter allows you to choose from a variety of lens types, from zooms to telephotos, and the Brightness slider can be used to cover any remaining editing errors.

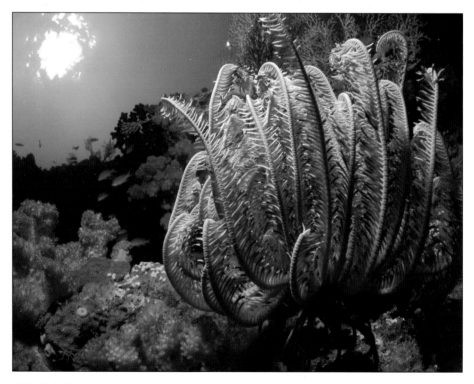

This digital camera image of a crinoid and soft coral has blooming, which was caused by shooting directly into the sun.

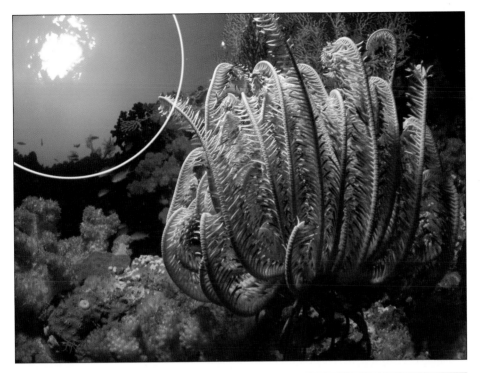

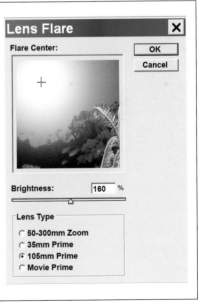

Above—A first step to a quick fix is done by selecting the area around the blooming effect with the Elliptical Marquee tool. **Right**—*Next, go to the Filter>Render>Lens Flare menu and select a point at the center of the blooming effect. Move the Brightness slider left or right until you have the desired effect.*

Add Sun Rays. If you want to add some sunlight streaks, you can use a combination of filters to create the effect. First, go to the Filter>Distort>Pinch and set the Amount slider to 100%. Then go to Filter>Blur>Radial Blur and set the Amount to 100%. Make sure to check the boxes for Zoom and Best Quality.

After you have done your final editing, you should zoom in at a very high magnification and look at the edge of the edited area to see if there are any differences in the noise pattern. If you find the edited area is smoother than the

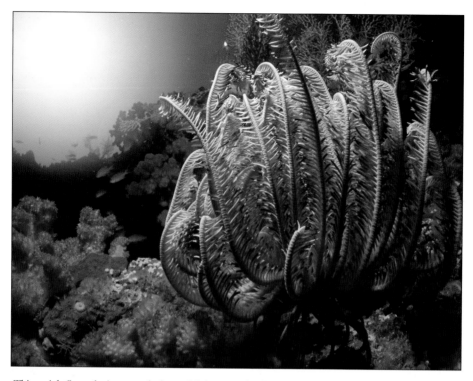

This quick fix technique works best with images that have a blooming effect out in open water.

outside area, go to Filter>Noise>Add Noise. Set the viewing area so you can see both sections, then move the Noise slider until the sections match. Zoom out, save the file under a new name, and be proud of yourself as you have just fixed a very difficult problem.

Fixing Blooming in RAW Files. RAW file shooters have an extra advantage of using the Curve tab in the RAW file editor. When you open a RAW file that contains blooming, make sure that you first check the Show Highlights box at the top of the menu. Click on the Curve tab and click a point at the top-right corner, then place another point about halfway between that point and the next grid intersection. This locks the curve in place so that your correction only affects the highlight area. Slowly move the upper point down until you have the effect you want. This clipping of the highlights doesn't provide quite as good results, but it sure makes quick work of a difficult problem.

Another solution when working with RAW files is to open the file at two different exposures, then combine them. Open the RAW file and adjust the image for the best overall exposure, ignoring the blooming effect. This will become your background image. Reload the file into the RAW file editor and adjust the

image for the maximum detail in the blooming area. Open this file in Photoshop and use Select>Color Range to select the blooming area. Copy this selection to the clipboard and paste it as a layer onto the background image. Combine the two using the same layer techniques shown at the beginning of this chapter.

Top Left—*Blooming effects can also appear in RAW files even though this format has a wider exposure range.* **Bottom Left**—*The quick fix in the RAW file editor is to go to the Curve editor and bend the top end of the curve. Place several points near the top of the curve, then move the top point down to reduce the sharp edge of the blooming effect.* **Top Right**—*The downside to this technique is that the highlights in the blooming effect might be off-white in color.*

*Top Left—A more advanced technique with RAW files is to adjust the RAW file until you have the best shadow and midtone values, ignoring the blooming effect. Then import the image into Photoshop. **Top Right**—Go back to the RAW file and adjust the image for the best detail in the blooming effect, then import that image into Photoshop. **Left**—Use the Select> Color Range command to select the blooming effect of the second image. Copy this image to the clipboard, and paste it into the first image as a layer. Select the thumbnail of this new layer, right click, and choose the Select Layer Transparency command. You can now add a layer mask to this layer. Reselect the thumbnail image and use the Filter>Blur>Gaussian Blur to slightly blur the layer. You can add further control by using the same Gaussian Blur filter on the mask. **Facing Page**—You can now control the effect of the repair by changing the opacity of the blooming layer and mask so that it mixes with the background image.*

○ Blooming Effect with Subject in Foreground

Subject Selection. More times than not, you'll find that your blooming effect is situated behind a diver, part of a wreck, or coral extension. Since you cannot use the Elliptical Marquee to select the affected area, you'll have to use a new approach. The first part of your task is to protect the subject and any nearby objects from your editing attempts. Since most subjects will be much darker than the blooming, you can use the Magic Wand to select the areas that you want to protect. If you find you can't select it all, or select too much, you can fine-tune your selection with the Polygonal Lasso using add (+) or subtract (−) icons. Inverse your selection, go to Select>Feather, and set the Feather Radius at 1–2 pixels. You will generally find too many tonal variables in the scene, so the Blur filters will rarely work.

Healing Brush. Go to the toolbox, select the Healing Brush, and be sure to set it to the Replace mode. Drag and drop data from just outside the blooming area to inside. Work your way back and forth until you have the area inside

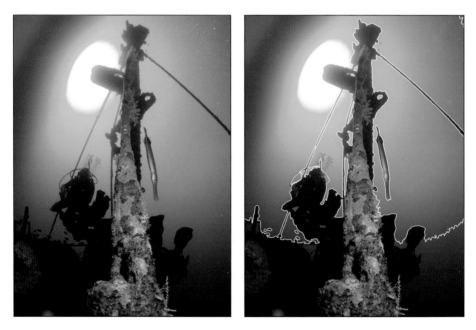

*Left—A more difficult blooming problem is when the effect is behind a subject as in this wreck from the Solomon Islands. **Right**—Using the Magic Wand and the Polygonal Lasso tools, the mast and dark foreground were selected away from the water and blooming effect. An inverse selection was used to choose the blooming effect and surrounding water.*

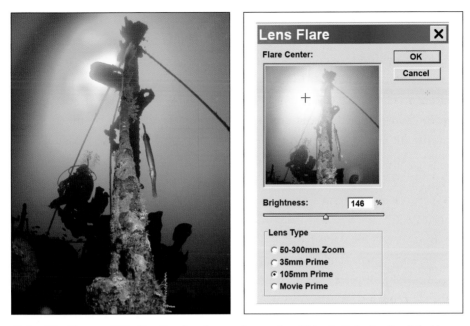

*Left—The Clone and Healing Brush tools were then used to fill in the light density of the blooming effect with darker surrounding colors. When using this method, don't worry about uneven editing, as it will all be covered up using the next step in the process. **Right**—The Filter> Render>Lens Flare filter was then selected and the pointer was placed in the middle of the blooming effect. The selection mask will keep the effect from spilling into the mast and darker foreground areas.*

the bloom filled with data. It doesn't have to look pretty, or be exact, as your editing errors will actually help the effect later.

Go to the top of the editing screen and set the Healing Brush back to the Normal mode, then go over the same areas again. This pass will smooth out some of the rough edges. It still does not have to be perfect. For the final touch, go to Filter>Render>Lens Flare and apply a lens flare effect to your selection. If you find that it doesn't totally cover the editing effects, use the Undo or Step Backward command and set the Brightness slider at a higher level.

In addition, there are several plug-ins that help solve complex problems such as this one. For more information on underwater plug-ins, check out chapter 15.

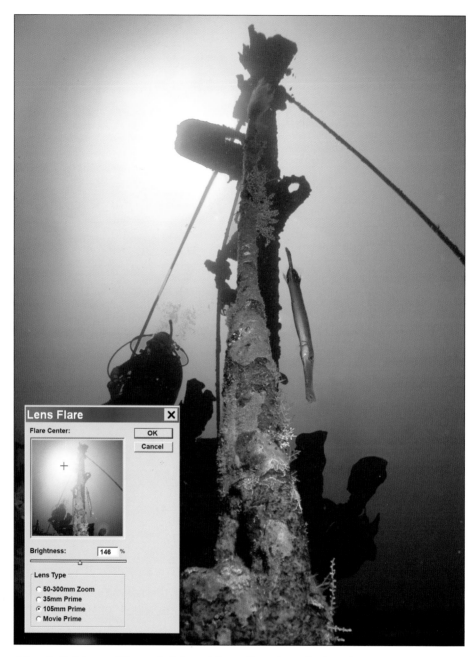

Move the Brightness slider to the left or right until you have the desired effect.

There are times when you have achieved correct exposure, accurate focus, and proper framing—but you still haven't captured the essence of the animal. In most cases this is due to problems with the background. Either the background is too busy or it is the same color as the animal, causing the animal to blend in. Often you can improve the quality of your results by opening your f/stop and reducing the depth of field, but you may also sacrifice important detail in the animal.

○ SELECTION TOOLS

The solution falls on Photoshop's capability to separate the animal from the background, and then adjust the background's visibility. This two-step process requires extensive knowledge of the selection tools. The tools of choice are the Polygonal Lasso tool, the Magnetic Lasso tool, and the Magic Wand. To maximize your editing capability, it's best to combine the strength of all three tools.

DRAGGING THE MAGNETIC LASSO ALONG THE EDGE WILL AUTOMATICALLY DROP SELECTION POINTS.

Before you even consider using one of the selection tools, it is important that you look closely at the contrast and color differences between the subject and the background.

Magic Wand. Creating a selection with the Magic Wand is an excellent solution when there is considerable tonal difference between the subject and the background. For example, a green nudibranch on a brown background will easily separate with the Magic Wand, even if the background is busy.

Magnetic Lasso. If the tonality of the subject and background are similar, your best bet is to activate the Magnetic Lasso. Set the tool to a size slightly larger than the edge that needs to be detected. Dragging the Magnetic Lasso along the edge will automatically drop selection points. (If it jumps to an area you don't want to select, use the Delete key to back up. Then manually click the mouse as though it was a Polygonal Lasso tool, and it will add points to

keep you in line. When you get to areas with more tonal difference, continue dragging the cursor along the edge, and it will automatically drop points along the line.)

Polygonal Lasso. Once you have made the selection with the Magnetic Lasso, you can go back with the Polygonal Lasso and fine-tune the selection by choosing the Add to Selection or Subtract from Selection icon in the upper-left corner of the editing screen. Now go to Select>Feather and set the Feather Radius to 1–2 pixels to blend the edge with the soon-to-be-modified background. To finalize your selection, go to Select>Inverse, or hit Shift+Ctrl/Cmd+I to inverse your selection.

○ BACKGROUND IMAGE ADJUSTMENTS

Levels Editor. With only the background area of your image selected, you can now open the Levels editor and reduce the midtone detail to separate the subject from the background. You can also use the right-hand wedge under the grayscale in the Levels editor to reduce the exposure in the highlights, which will also help the separation process.

Saturation. Another solution is to press Ctrl/Cmd+U keys and open the Hue/Saturation menu. You can change the hue, brightness, and even lower the saturation of the background so that it appears flatter

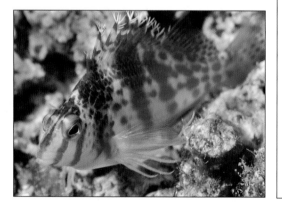

Above—This is a good example of a subject that blends into the background. The fish will be difficult to separate from the background because of its fine detail and the fact that the focus falls off toward the tail. Left—The Magnetic Lasso tool is the tool of choice for this selection, and it can be accessed by clicking on the small black arrow in the Lasso tool field.

than the subject. Care must be taken not to overdo the effect; otherwise, it will look like the animal was plucked out and pasted on a different background. With any of these solutions, you will find a few light spots in the background that still detract from the main subject. You can use either the Clone tool or the Healing Brush to easily blend these bright objects into the background.

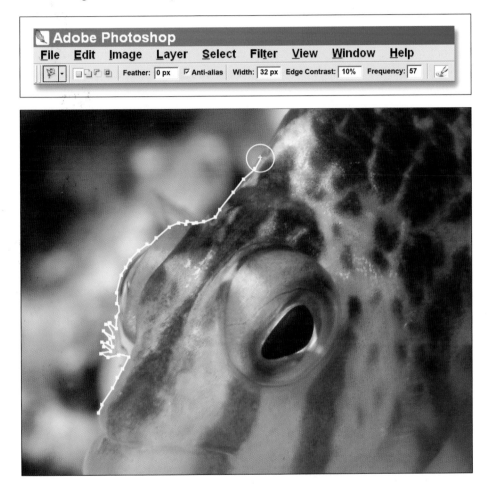

Top—When you select the Magnetic Lasso tool, the Options menu bar appears at the top of the editing screen. You can make a single selection, add to or subtract from the selection, or use the intersection of selections. You will find the Feather setting and also the Anti-alias box, which is usually checked to keep the edges of your selection smoother. The Width box determines the size of the work area, and the Edge Contrast determines what contrast is needed to make a selection. The Frequency box determines how often points are dropped as you move along with the Magnetic Lasso. The higher the number, the closer together the selection points. Above—This enlarged section shows how the Magnetic Lasso tool works as it moves along the edge of the fish.

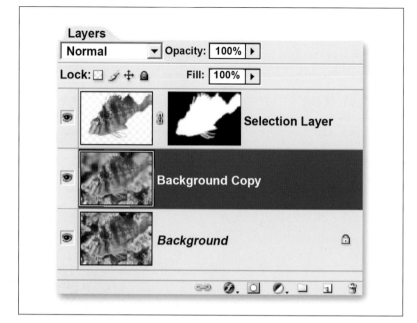

Layers

Normal ▾ Opacity: 100% ▶

Lock: ☐ ◢ ✛ 🔒 Fill: 100% ▶

Selection Layer

Background Copy

Background

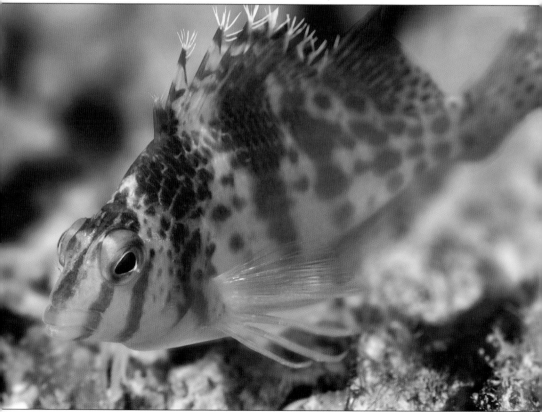

Facing Page—(Top) The bottom layer (Background) is the original image. The Background Copy layer was used to adjust the focus, brightness, saturation, and/or contrast. The selection of the fish was copied to the top layer using the Ctrl/Cmd+J keystroke. A layer mask was added after right clicking on the thumbnail and using the Select Layer Transparency command. (Bottom) This image shows the effect of the Blur filter. *Above*—This is the final image after contrast, brightness, and saturation changes were made to the Background Copy layer.

○ EXTRACT FILTER

If you want an even more sophisticated method for selecting image areas away from backgrounds, you can try your hand at using the Extract command. When you open this plug-in from the Filter pull-down menu, your first task is to zoom in on an edge that you want to separate. You then select the Highlighter Pen from the Extract "toolbox" and mark all the edges you want to keep. Once you go completely around your selection, you can use the paint bucket to fill in the rest. Check the Smart Highlighting box to help speed up the process along areas with well-defined light edges.

After you click OK, you are dropped back into Photoshop with a very accurate mask of the subject. You can then move the selected subject from background to background or paste it back into the original image. If you find that the Extract function has captured more data than you want, you can use the Eraser tool to remove sections from the layer. If you set the Eraser tool to 10–20%, you can drag it across small fish fins to make them transparent. This

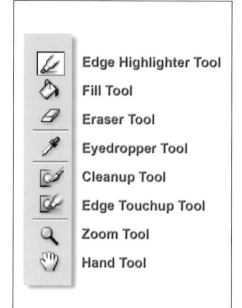

Facing Page—The extremely complicated features of this Fijian lionfish make it difficult to create selections using the Lasso and Magic Wand tools. **Top Left**—*When you go to Filter>Extract, this toolbox will be displayed along with your image. Moving your mouse over the tools will display the lines of text shown. The Edge Highlighter is used to draw along the selection edges and the Fill tool will fill in any closed areas. The Eraser tool erases unwanted areas of the selection, while the Eyedropper tool selects the colors you want to keep. The Cleanup tool and the Edge Touchup tool are used to fine-tune your extraction. The Zoom and Hand tools allow you to navigate around your image as you extract an edge.* **Top Right**—*This enlarged section shows how the Edge Highlighter is used to find the selection edges.* **Bottom Right**—*This is the lionfish image with the completed Edge Highlighting.*

Facing Page—*(Top) The Fill tool was then used to fill inside the selected area. (Bottom) this image shows the lionfish selection on a transparent background after the Extract filter was used.* ***Above***—*The extracted Lionfish was copied and pasted onto a black background.*

is a very powerful selection tool, but becoming proficient in its use takes some practice, so be patient.

○ LENS BLUR

Probably the most effective method for separating subjects from the background is to modify the depth of field in the image. Normally, it is best to attempt this as you are shooting the image, but we'll show you how you can accomplish the effect after the image is taken.

One way this can be accomplished is via Filter>Blur>Lens Blur. The quality of the Lens Blur filter is outstanding, but its complexity makes it difficult to

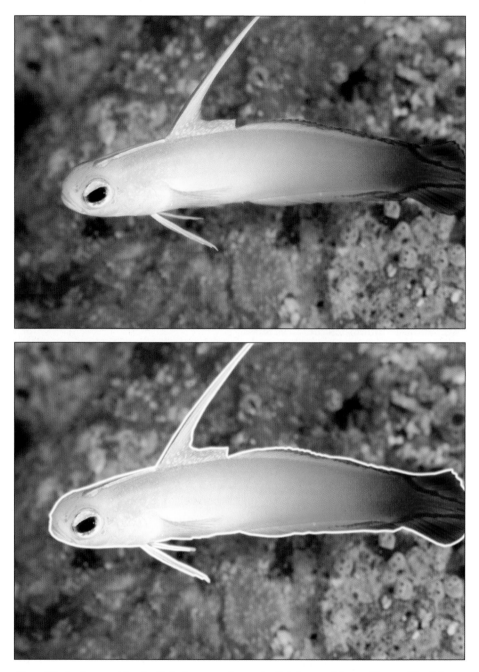

Top*—The background in the digital camera image is slightly out of focus.* ***Above****—The fish was selected using the Polygonal and Magnetic Lasso tools.*

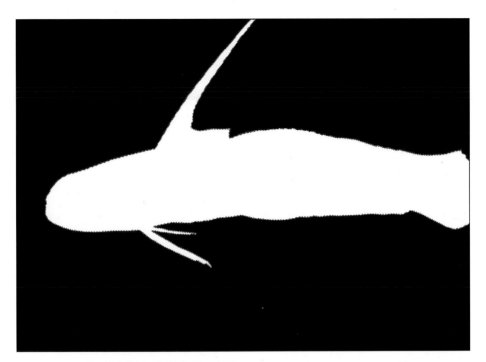

When the selection is saved, it will appear as a black & white channel.

use. Even that won't stand in your way once you see its potential, so here goes.

Save the Selection as an Alpha Channel. The first step in using the Lens Blur filter is to save the portion of the image that you have selected away from the background. When you save this selection (Select>Save Selection), you create what is called an Alpha channel in the Channels palette. Make sure that the selection marquee is visible. If it isn't, go to Select>Load Selection and reload the saved selection. Then reverse the selection with the Select>Inverse command so that you have the background selected.

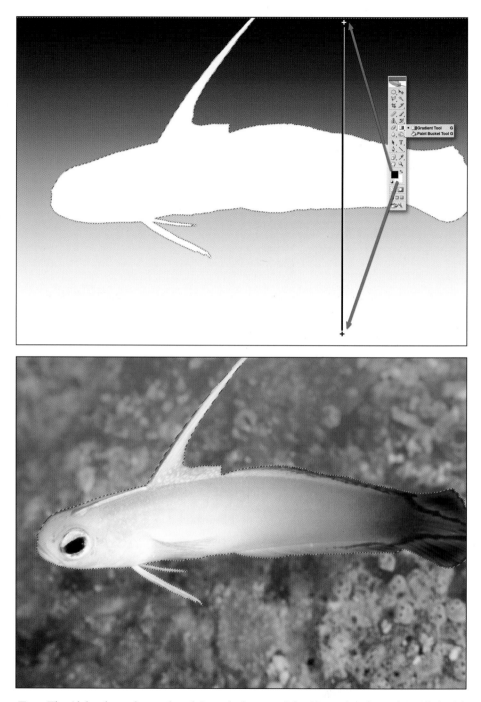

Top—*The Alpha channel was selected from the bottom of the Channels palette, then filled with a Gradient Fill from top to bottom.* ***Above***—*When you click the RGB channels back on, you will be presented with an image that shows the original and the gradient mask.*

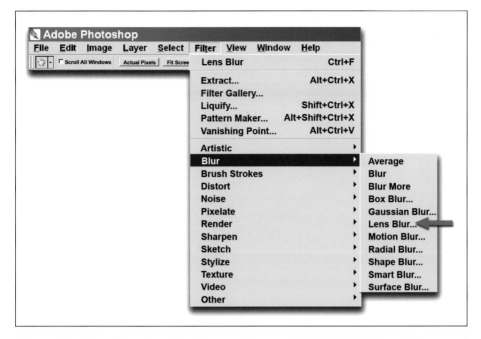

Above—The Filter>Blur>Lens Blur filter can be accessed from the top of the editing screen. Right—When the Lens Blur menu opens, you are presented with several options for creating a Lens Blur effect. The critical settings are the Source (Alpha 1), Blur Focal Distance (255), Invert (unchecked), and the Radius (100).

Gradient Fill. Now go to the toolbox and set the foreground to black and the background to white. Look at the Channels palette and make sure that you have the Alpha channel selected. The RGB channel may be turned off, so turn it back on by clicking on the eye icon. Move to the Gradient Fill and click on a point at the top of the screen, then drag to the bottom. A graduated mask should now appear from top to bottom. In the Channels palette, select the RGB layer (instead of the Alpha Channel).

Apply Lens Blur. Now go to Filter>Blur> Lens Blur, and don't be afraid if your image opens up with everything out of focus. This is

because you haven't ever used this command before (or it has reverted to the last settings you used). To properly set the menu options, set the Source to the Alpha channel and the Blur Distance at 255. This should put the focus point at the bottom of the image. If you find the foreground is out of focus, uncheck the Invert box or set the Blur Distance to 0. The Radius slider determines the degree of blur, and it will provide full lens blur when set at 255 and none if set to 0.

You will note that there are dozens of other controls in this very complex filter. Play with them one at a time to see what each does. Keep in mind that it takes a long time for this filter to do its job, so you might want to take a coffee break. We recommend that when you first try this filter, you practice on an image scaled down to 1024 pixels on the longest side. Once you get it working, you can tackle larger files. Since it is so complex, we also recommend that you make an Action to automatically complete these steps with other images.

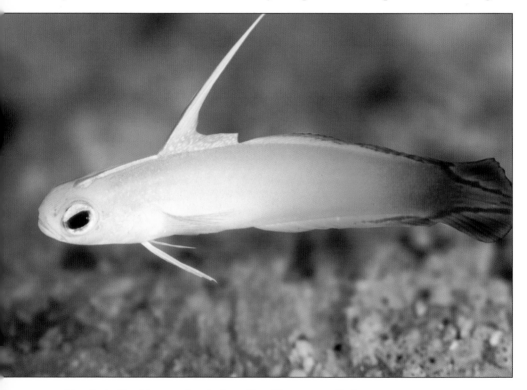

Here is the final image after the Lens Blur filter was applied.

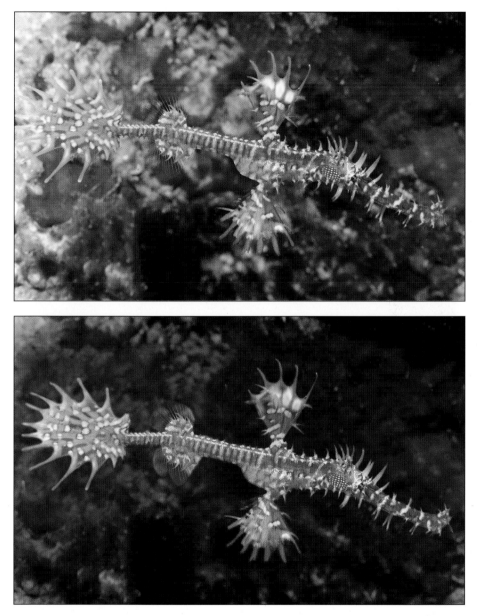

Top—*This ghost pipefish has very fine detail that blends into the background.* ***Bottom***—*The fish was selected with the Polygonal Lasso tool and copied to a new layer. Next, the background was blurred with the Lens Blur filter. The Eraser tool was used on the selected layer to allow the transparent fins to show through.*

15. UNDERWATER PLUG-IN APPLICATIONS

To get the most power out of Photoshop, you should consider installing several third-party plug-in filters. These specialized filters offer image correction and manipulation options to help your editing process. At last count there were more than 10,000 of these filters on the market, and they enable you to do just about everything you can imagine! The bulk of these filters are simple to use and cost very little or come as a free download. There are about 300–500 commercial-grade plug-ins that cost a bit more but offer some of the best imaging effects ever.

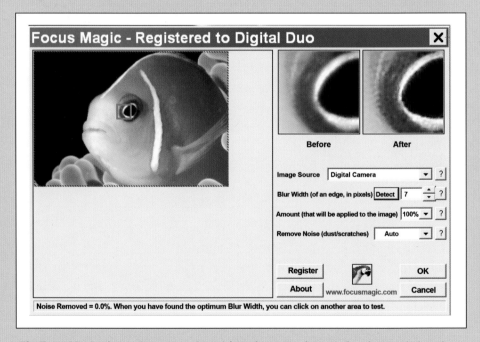

The Focus Magic plug-in is very popular with underwater photographers because it is easier to understand than Adobe's Unsharp Mask. It asks you to select the type of image (film, digital, etc.), automatic blur width, amount, and the type of noise reduction needed. A large navigator window is in the upper-left corner of the menu, and there are before-and-after thumbnails in the upper-right corner of the menu.

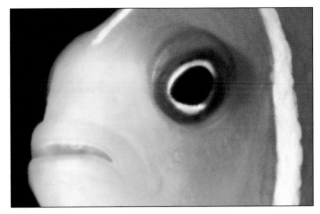

Right—A close-up section of this clown fish shows that the image is soft in focus. Below—The final image shows a marked increase in sharpness.

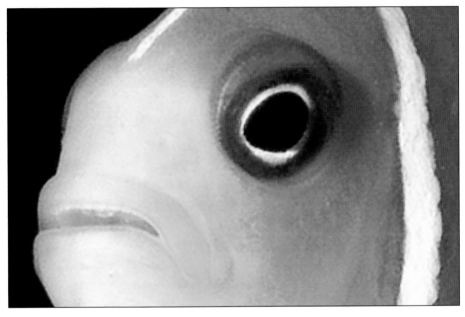

The plug-in world is so big that we have devoted an entire book to the subject called *Plug-ins for Adobe® Photoshop®*, also from Amherst Media. If you are really serious about editing your underwater images, you should add this book to your editing resources. The plug-ins listed below are some that we consider essential for underwater image editors.

○ FOCUS MAGIC

www.focusmagic.com

If you are having trouble understanding and working with the Radius, Threshold, and Amount sliders used in Photoshop's Unsharp Mask or Smart Sharpen functions, you might want to consider trying the Focus Magic plug-in. When

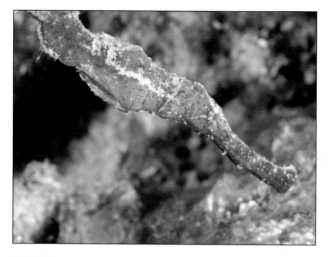

Top—*To protect itself from predators, the ghost pipe fish carefully camouflages itself against the background, but this makes viewing an image of it very difficult.* **Center**—*Andromeda's VariFocus plug-in filter works much like the Lens Blur filter, except that many of its features are automated, which makes it easier to use. First select the fish away from the background and then inverse the selection. Open the Filter>Andromeda>Vari Focus filter, and select the desired gradation from the lower-right box. Rotate the effect if necessary before you move the slider on the lower left to increase or decrease the amount of defocus. A big advantage to this filter is that you can select the center point of the focus and, as you move it to a different position, the results are updated in the large preview screen.* **Bottom**—*This final VariFocus image gives the appearance of a rotated depth of field, which allows the fish to more easily separate from the background.*

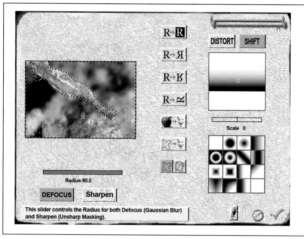

you start this program, it guides you through the sharpening process with simple and easy to understand questions. It asks about the type of image you are sharpening and just how much you want to sharpen it. The plug-in takes a considerable time to sharpen the image, which makes us assume that it is working hard and doing a superior job. In all of the images where we have used Focus Magic, we have found that this plug-in beats all the Photoshop sharpening tools hands down.

○ ANDROMEDA VARIFOCUS

www.andromeda.com

In chapter 14, we showed you a complex method for changing the depth of field in an image. Now you can take that same image with its selected subject and create an effect similar to Photoshop's Blur filters. The difference is that Andromeda's filter is much easier to use, features more control over the depth-of-field settings, and renders the image in a fraction of the time. If you take photos of fish and other critters in open water, this plug-in is a must.

○ AUTOFX MYSTICAL LIGHTING

www.autofx.com

This is one of our favorite plug-in filters. With this plug-in, you can add light beams to any type of light source. The best part of all is that this filter duplicates real-world lighting so well that you would be hard pressed to tell that the effect isn't real. The beam

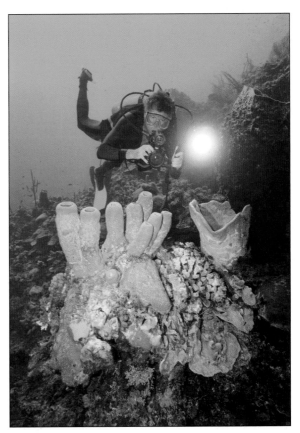

This film image was taken of a diver with his flash set to slave. The image looks good but could be further enhanced.

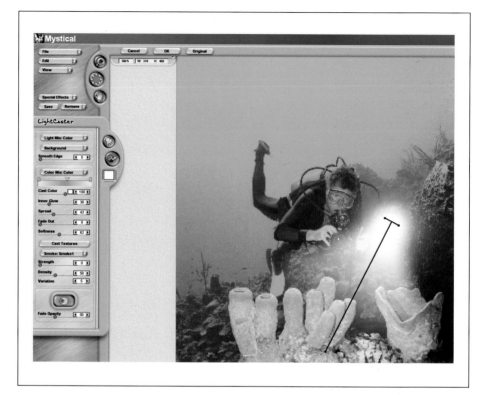

Above—The Light Caster plug-in from AutoFX allows you to add Hollywood-style beams of light. After the plug-in is loaded, click on the screen and a T-shaped icon will appear. Stretch the top of the T to match the width of the exit point of the light and assign the bottom of the T to a beam direction. Slider controls in the plug-in allow you to change the beam angle, adjust light falloff, or alter the softness and color of the beam. **Facing Page**—*The Light Caster plug-in can be applied directly to your image, but if you want even more control, apply it to a separate layer.*

itself can be rotated and/or extended, and its angle can be changed. The filter even follows the laws of physics, producing light falloff and soft edges as its light projects out from the source. This filter is a must for images with a camera flash or flashlights in the scene.

O DIGITAL ELEMENTS AURORA

www.digitalelements.com

If you like to put on digital slide presentations for your local dive club, there is a special plug-in that creates real-world backgrounds. We use this for all our lecture titles. This plug-in takes a blank image and creates skies, clouds, water,

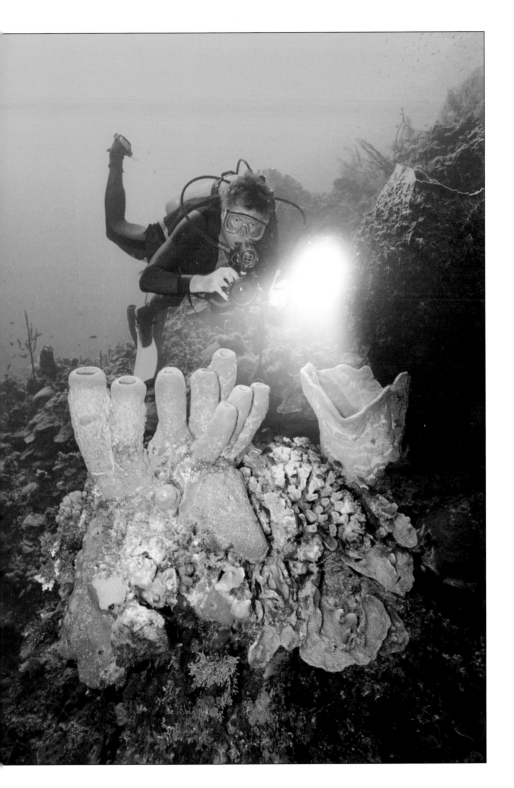

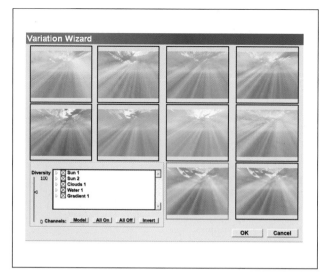

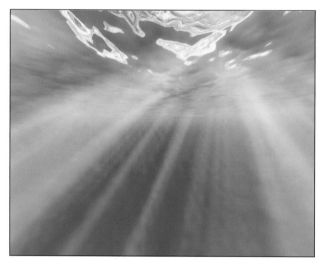

Top—*A variety of creative underwater backgrounds can be produced with the Digital Elements Aurora plug-in filter. This plug-in creates backgrounds for sky, sun, clouds, and land- scapes, but the underwater options are unique. There are dozens of controls for camera angle, distance underwater, sun bright- ness, refraction, water color, and clarity of the water. Once you have an image you like, you can cre- ate several variations that can be saved and recalled later. Bottom*—*This plug- in can be used on a blank image or applied to any of the layers in a nondestruc- tive editing environment.*

or sunset imagery. Most importantly, it has a full section for creating under- water background scenes, complete with sun rays filtering down through the waves. Once you have your scene picked, you can use a Variations command to slightly alter the background for even more options.

○ COREL KPT LENS FLARE

www.corel.com

In chapter 13, we used the Photoshop Lens Flare filter to remove the bloom- ing effect in a photo. Corel's KPT version of the Lens Flare filter is much more powerful and has dozens of preset flare controls. You can even save each of

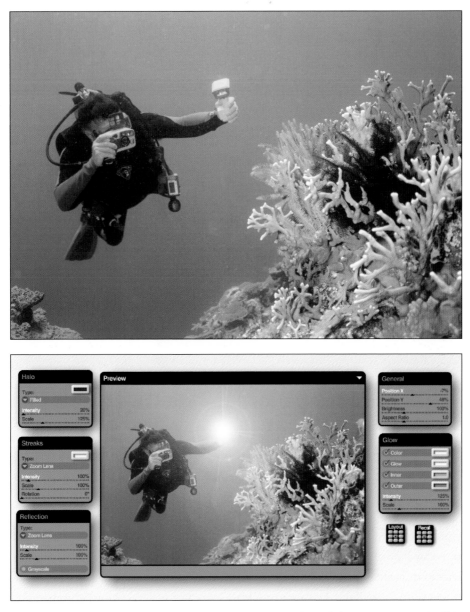

Top—*This image of the Sea & Sea MX-10 camera was taken while on assignment for* Skin Diver. *Years later we decided to jazz the image up for use in lighting lectures.* **Above**—*The Corel KPT Lens Flare plug-in was opened and applied to the image. You can position the lens flare directly on the thumbnail preview by clicking on the spot where you want the flare. Submenus give you control over halos, streaks, reflections, and the glow of the flare. There are also dozens of presets that can be applied to the flare.*

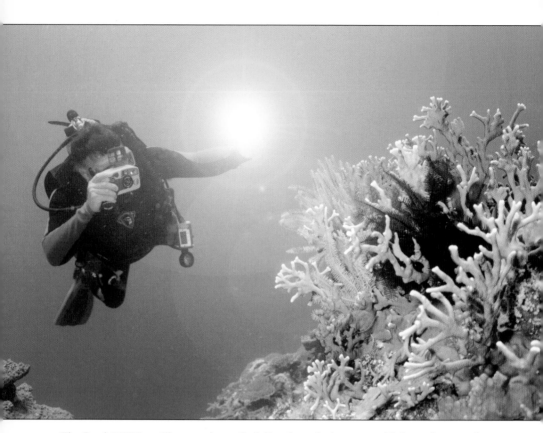

The Corel KPT Lens Flare can be applied directly to the image or added as a layer to give you more opacity and location control.

your favorite settings and recall them later. If your images have blooming problems, then this is a great tool for making them fade away.

There is another use for this filter that has nothing to do with correcting blooming effects. Using a slaved flash underwater is difficult because digital cameras are very sensitive to direct flash. The solution is to shoot the image with the slave turned off, or on extremely low power. You can then add back the flash with the KPT Lens Flare filter.

○ EXTENSIS MASK PRO 3
www.extensis.com

In several chapters we talk about selecting subjects away from the background using the Lasso tools, Magic Wand, or the Extract filter. The Mask Pro 3 works much like the Extract filter, but it features even more control over the extraction process. This filter uses a method of compiling a palette of designated col-

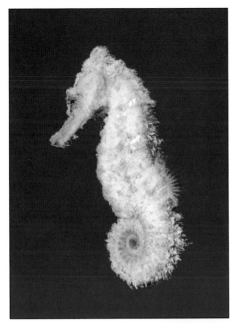

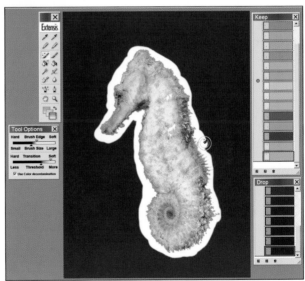

*Above—This film image of a seahorse on a blue water background looks good but could be improved. **Top Right and Bottom**—Mask Pro was a product of www.extensis.com until recently, when it moved over to www.onOnesoftware.com. It is similar to Photoshop's Extract filter but features more controls. When you open an image, click on Keep and Drop colors to build color palettes that will be used by the masking brush. Once the colors are selected, move the brush along the edge of the subject and a mask will be created. Once you have marked the edges, you can fill in the remaining area with the Paint Bucket tool. Additional tools allow you to touch up and refine fine detail that may not have been accurately masked.*

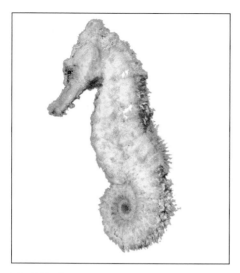

Left—*Once the mask is created, you can open the image in Photoshop, where a high-resolution selection of the subject will become visible.* **Below**—*The selected seahorse can then be combined with a new background image such as the one we created with the Digital Elements Aurora plug-in shown earlier.*

ors you want to keep or drop. The program allows you to easily select colors inside the subject to keep and colors in the background to drop. The program is also very good at masking fins so that they have a transparent appearance when separated away from the background.

○ **ALIEN SKIN SMART FILL**
www.alienskin.com
In chapter 11, we showed you how to heal dead coral with the Healing Brush. If you find that your Healing Brush attempts have not done the job, you might consider using this plug-in. First, select the area to be repaired, and then jump in with the plug-in. It will automatically repair the area and even provides addi-

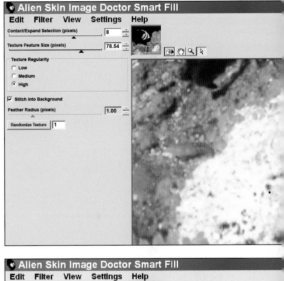

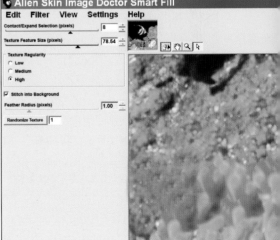

Above—Several white or dead coral areas seem to draw attention away from the fish.
***Top Right and Bottom Right**—The dead coral areas are selected before going to Filters> Alien Skin>Image Doctor>Smart Fill plug- in filter. The filter will zoom in on the select- ed area and magically remove the offending area by using the surrounding data for auto- matic cloning. Sliders provide control for expansion or contraction of the selected area as well as texture and feathering options.*

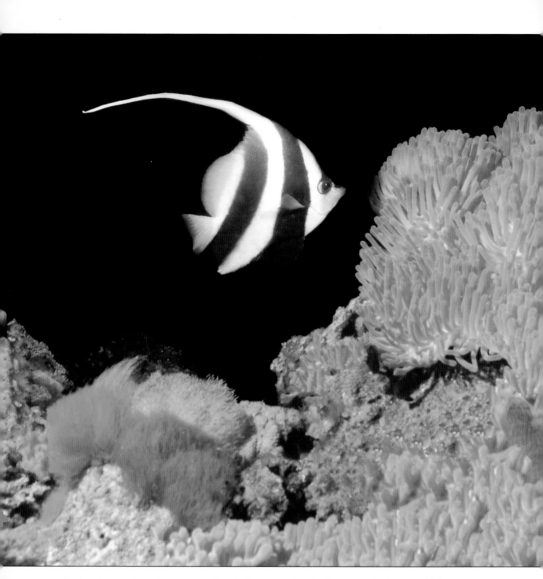

In less than a few minutes this plug-in has very effectively removed what would have taken considerably more time using the Clone tool and the Healing Brush.

tional blending and feathering tools to make the repair completely invisible. This is one of the most impressive repair filters we have seen to date.

○ GENUINE FRACTALS PRINT PRO

www.onOne.com

If you plan to make some extreme enlargements from a small image, you will need to resize the image before printing. Otherwise, you will end up with jag-

Top—When you need to make large prints from images that are too low in resolution, the onOne Genuine Fractal Print Pro (Formerly Lizard Tech) can be applied. The navigator thumbnail is in the upper right, and the large thumbnail preview of the results takes up the left half of the menu. Options allow you to scale, crop, save settings, or use a preset. **Center and Bottom**—*This enlarged section of the crinoid image shows the jaggies, and the final image shows how they were removed with the Genuine Fractal Print Pro plug-in.*

gies along the sharp edges in the image. Photoshop offers variations of the Rescale Image command, but none compare to the power of this third-party plug-in filter. This is the filter used by most printing houses to enlarge digital files for offset printing.

To use this plug-in, go to the onOne pull-down menu or to File> Automate>Genuine Fractals PrintPro, scale the image to a new size,

and save the file. One big advantage to this plug-in is that you can do some extreme sharpening to the files after they have been enlarged.

○ EXTENSIS PHOTO CAST SHADOW

www.extensis.com

If you like the shadow effect, then this plug-in is a great way to add depth to your selected object. When you bring a selection into this menu, you can use a marquee to manipulate the shadow. You can drag it to any shape you desire, either in front of or behind your subject. Additional sliders allow you to numerically set the distance, blurring effect, and the direction of the shadow.

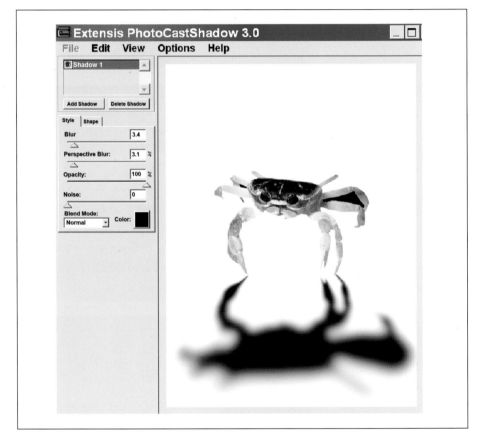

If you find that copying and pasting layers looks unnatural, it may be because you need a shadow to add dimension. The PhotoCastShadow plug-in from Extensis takes the new layer and adds a dimensional shadow marquee. You can grab handles on the marquee and stretch them to any position. The filter's sliders allow you to alter the Opacity, Perspective Blur, and Blending Mode.

If you want maximum control over your sharpening filter, the FocalBlade plug-in from www.thepluginsite.com is your best bet. This filter gives you options that are far beyond those found in either the Unsharp Mask or Smart Sharpen filter. This impressive filter allows you to separately control sharpening in the shadows, highlights, and midtones, for both edge and surface detail. The menu comes in an expert or basic mode and provides single- or split-view configurations. With this image, we first sharpened the edges and followed by sharpening the surface settings. We moved the Radius slider until we had the desired results.

○ THE PLUG-IN SITE

www.ThePluginSite.com

This is one of the biggest resources for Photoshop plug-ins on the Web. The site has hundreds of links to thousands of actions, plug-ins, tutorials, and other related Photoshop tools. In addition, the site has the Plug-in Commander Pro for keeping track of and managing your plug-ins.

Three plug-ins that apply to underwater photography are the Color Washer, the Light Machine, and Focal Blade. The primary task of the Color Washer is to correct color casts and color shifts. The Light Machine is used to correct

lighting problems such as poor exposure, shadow detail, and contrast and saturation issues.

Focal Blade is a plug-in that provides maximum control for separately sharpening edges, surfaces, highlights, and shadows. These plug-ins are the Swiss Army knives of plug-in filters, since they have just about every possible option available for solving their specific problem area. It would take several pages to illustrate all the features found in these plug-ins.

Top—Another filter from www.thepluginsite.com provides maximum control and options over color casts and shifts. This menu has so many features it may take you a while to become familiar with them all. When starting out, try the auto modes under the Cast folder, then go to the Color folder and tweak your color, contrast, and saturation. The bottom half of the options give you full control over both highlights and shadows. In this image we used the Auto1 Cast selection and modified the brightness with the Color folder. The highlights and shadows were tweaked slightly until it looked just right. **Bottom**—*The Light*

Machine from www.the pluginsite.com is used to correct problems with color, exposure, contrast, and saturation. This plug-in has nine separate modes that work in either Basic or Pro levels, so there are hundreds of possible combinations of controls in this plug-in. We used the Colors Pro, Brightness/Contrast Pro, and Shadows/Highlights Pro modes to lighten this image while maintaining a nice tonal range.

○ Kodak Digital GEM, ROC, and SHO Pro

www.asf.com

These three plug-in filters got their start with Applied Science Fiction and have evolved to a series of Kodak professional-level image correction filters. The Digital GEM filter is designed to reduce film grain and digital camera noise and still maintain fine image detail. The Digital SHO filter is designed to compensate for loss of midtone detail, which is very common in underwater photos.

Digital ROC was designed to restore color in faded or damaged images. Since many underwater lighting situations lack color, especially when using available light, this filter can do a great job of correcting bluish-colored images.

○ New Plug-ins

New plug-ins are always being introduced, and existing ones are sometimes improved. We try very hard to stay on top of the latest offerings and innovations, so check out our plug-in links at www.jackandsue drafahl.com.

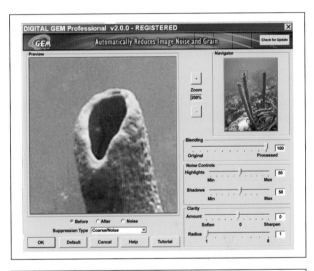

This 3MP digital camera was set to a high ISO speed, which resulted in a large amount of digital noise. The Kodak Digital GEM plug-in filter was applied to the image, which dramatically reduced the noise while retaining image detail. Additional sliders provide options for adjusting the blend between the original and processed image, highlights and shadows, and clarity of the image.

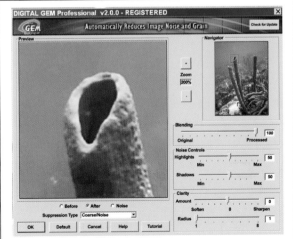

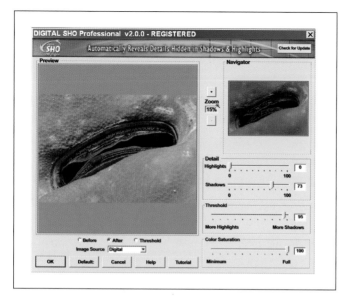

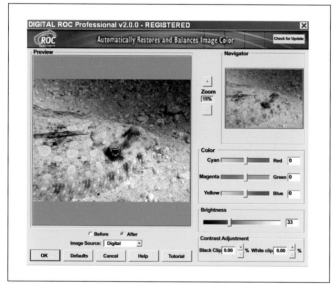

Top—This underexposed digital image of a scallop buried in hard coral was corrected with the Kodak Digital SHO plug-in filter. This filter automatically makes the correction but allows you to use sliders to further tweak highlights, shadows, and saturation. Above—This digital camera file of a flounder has a drastic cool shift. The Kodak Digital ROC plug-in was used to automatically correct exposure and color balance. Additional sliders can control color balance, brightness, and contrast.

16. ADVANCED LAYERING TECHNIQUES

Once you have your images edited to perfection, you are ready to move on to the next step. If you want to work on lecture images, print posters, or design displays, brochures, or even a website, you need to venture into the world of layers.

We've been working with Adjustment Layers for some time now, but now we will create an advanced layer, a collage of images with added text and shapes. Although it may look complicated, the task is simpler than you think, as you are already familiar with most of the necessary tools.

○ DIFFERENT PHOTOSHOP VERSIONS

The biggest problem you'll face is Photoshop's version changes. From Photoshop 7 to Photoshop CS, there is very little visible change to the Layers palette, but from CS to CS2, it's a whole different story. In this chapter, we'll present separate tips (as needed) for Photoshop CS and CS2 users. Those still using Photoshop 7 can use the CS information as their guideline.

Open the Layers palette via Window>Layers or by pressing the F7 key. Move this palette to the side of your editing screen (or to your second monitor) so that you have room to work. Now open a new file (this will be your master file) and set the dimensions for your final product. The size of the page can either be in pixels or in inches with dpi settings.

WE'VE BEEN WORKING WITH ADJUSTMENT LAYERS FOR SOME TIME NOW, BUT NOW WE WILL CREATE AN ADVANCED LAYER....

○ PHOTO COLLAGE USING FULL IMAGES

If your final project will be a collage of underwater images, you should start by opening the images you want to include in your poster. Using the Move tool, drag and drop a copy of each image onto the master page, then close the source images. When you bring the different images into the new background, you may find that some are too large. To change the size of an image, go to

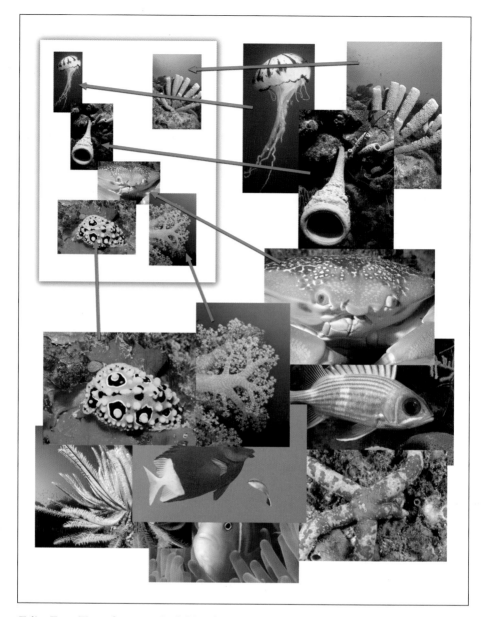

Edit>Free Transform or Ctrl/Cmd+T and right click on the marquee. You can also rotate, warp, and distort the image—or whatever effect you desire.

Smart Objects. In Photoshop CS, if you scale an image down and double click on it, the layer will be at the new lower resolution. If you then decide to use the Transform options to take it back up in size, it will maintain the lower quality of the smaller size. The creators of Photoshop CS2 have devised a plan to rectify the problem.

Facing Page—When creating a composite image you should first create a blank image, then drag open images onto that new image. Close all the source images before starting to work on your composite image. **Top—***If you find that the images you imported are too large, you can select that layer and press Ctrl/Cmd+T, then right click to select the Scale function.* **Bottom—***As you add images to your composite, you can click on the images directly and move them to a new position, assuming that you have clicked the Auto Select Layer box.*

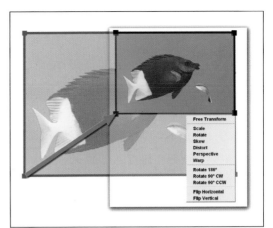

First you will need to go to Layer>Smart Objects>Group into New Smart Object to convert the layer into a Smart Object. Photoshop will then keep track of the original resolution no matter how you transform the layer. A small Smart Object icon will be visible in the Layers palette.

Moving Layers. If you want to move the images into position, you can select a specif-

ic layer from the Layers palette or check the Auto Select Layer box at the upper-left corner of the main editing screen. With this box checked, you can

Right—If you have several layers and are having trouble keeping track of them, you can select each layer and rename it. Center—When you want to align or distribute selected layers, you can go to the icons at the top of the editing screen and choose the command that applies. Bottom—The three main options for layer selection are located at the top of the editing screen. Auto Select will automatically select any image layer you click on. This saves time as you don't have to go to the Layers palette. If you have layers in groups, then check the middle box to automatically select groups. Finally, if you want the Transform handles to automatically appear on a selected image, check Show Transform Controls.

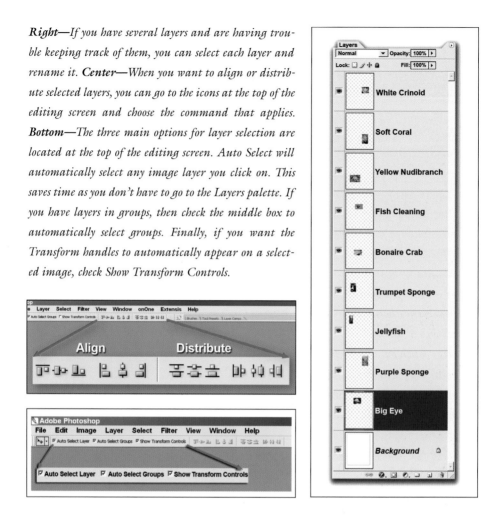

place your Move tool cursor over any image, then grab it, and change its position.

Add a Shadow. Your next step is to add a drop shadow to each layer for better separation between layers. The Layer Styles palette can be accessed either by Layer>Layers Styles, or by pressing the "f" icon at the bottom-left side of the Layers palette. When you select Drop Shadow, you are presented with a new menu featuring several drop shadow options. You can use the Distance slider and the Angle dial to set the x and y position of the drop shadow. Then you can use the Size, Spread, and Opacity sliders to soften the shadow effect.

Copy the Shadow in Photoshop CS. Once you have the shadow properly positioned, you will want to copy it to the other images and maintain the same settings. In Photoshop CS, you can drag the shadow effect from one layer

Above—*When you open the Layer Styles menu from the Layer pull-down menu or the Layers palette, you are presented with a dozen blending options. Checking the box turns the option on, then a submenu opens featuring controls for that Layer Style.* **Right**—*When in the Layers palette, these are the Layer Style options available. When you make your selection, a submenu listing more options will appear.*

down to each of the others. You can also right click on the layer with the drop shadow and copy the layer effect to memory. You can then select another layer, right click, and paste the shadow effect into that image layer.

If you have several layers in which to place the shadow, you can use the Link icon (next to the thumbnail image) to link all the remaining layers together. Note that when layers are linked in CS they work as one. Select the shadow layer, copy it to memory, and then right click on the group to select Paste Layer Style to Linked. This will add the same layer style to all of the linked layers.

Copy the Shadow in Photoshop CS2. Photoshop CS2 users have it a little easier. Create your drop shadow on the first layer just as you would in CS. Then select the other layers in the Layers palette by pressing and holding the Ctrl/Cmd key and clicking on each individual layer (to add one image at a time), or press the Shift key and click on the first and last layer—those two layers and everything in between will then be selected. You can then right click on the group of selected images in the Layers palette and paste the drop shadow effect or move the images as a group.

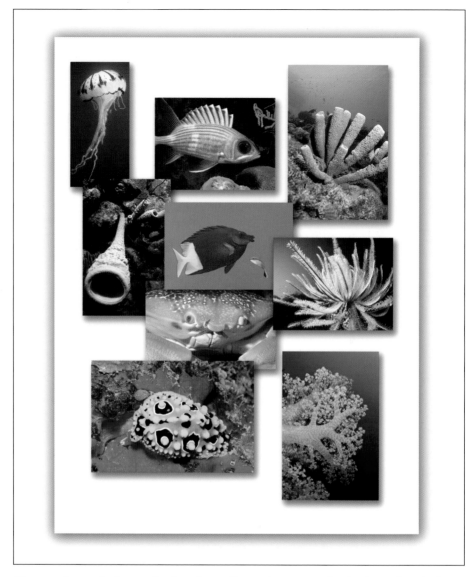

You can change the layer order by going to Layer>Arrange, or by simply moving the layers around in the Layers palette. Once the position is set, you should save the composite file as a PSD file so you can edit the layered file later.

Grid Alignment. Layer alignment in Photoshop CS can be done by going to View>Show>Grid then View>Snap To>Grid. When you select or move any of the layers, they will jump and align themselves with the lines in the grid. You can also select several layers and use any of the Align and Distribute icons at the top of the editing screen to make your adjustments.

To see what each icon does, hold your cursor over the icon, and you will see a message explaining its use. You can also drag guides from the left and top edges of the screen and go to View>Snap To>Guides. When you move the layers close to the guides, they will jump to the guides. This allows you to easily create a custom alignment.

Auto Guides. Photoshop CS2 users can access all the tools found in CS and can also take advantage of the Auto Guides functions. As you move layers around on your master image, guides will automatically appear and disappear as the edges or center of each layer passes another. This new feature makes image alignment fast and easy.

Arranging the Layers. The stacking order of the different layers can be changed by going to Layer>Arrange and selecting the best order. You can also go to the Layers palette and drag the layers into a new order with the uppermost layer being the composite's top image.

○ PHOTO COLLAGE WITH SOFT EDGES

A very popular type of image collage is when the images have soft, rather than hard, edges. Begin by creating a new blank master image, then open the photos to be used in the collage. Choose one of the shots and use the Lasso tool to select the essence of the image. The selection can be any shape or size as long as it does not get too close to the edge. Feather your selection from 35–50 pixels, depending on the size of the new image.

If you hold down the Ctrl/Cmd key while the Lasso tool is still selected, you can move your selected image element onto the new background. Another option is to use the Move tool to drag the selected part. Do the same with all the other images until all

A VERY POPULAR TYPE OF IMAGE COLLAGE IS WHEN THE IMAGES HAVE SOFT, RATHER THAN HARD, EDGES.

of the soft-edged images are on the new background. Click on the Auto Select Layer function at the top-left of the main editing screen to move and position the images.

You may find that you have selected more area than you intended on a given layer. To fix this, simply zoom in on that layer, and slowly remove the area you don't want using the Eraser tool, then proceed with your collage as described above.

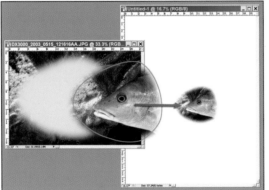

Top—To create a soft-edged selection, you first must use the Lasso tool to draw around the area you want to import into your new image. ***Center and Bottom***— Create a heavy feather for the selection (25–50 pixels) before dragging it to the new image background. The layer should have a very soft edge. If it doesn't, simply Undo or Step Backward and use a heavier feather setting.

○ Blending Modes

Whether you are working on a hard- or soft-edged collage, you can take advantage of layer blending modes. In the Layers palette, you will find a blending

mode pull-down menu featuring almost two dozen different types of blends. Each blend varies the contrast, opacity, saturation, and brightness in different combinations. The only way to see what each one does is to select a layer and give them each a try. You can use the Shift and + key combination to quickly work your way down through the list to see how each blending affects that layer. You also have the option of changing the opacity manually using a slider control.

○ Layer Mask

One of the most powerful tools when working with layers is the Layer Mask. To add a Layer Mask, go to the bottom of the Layers palette and click on the square icon with a white circle in the middle. This will bring up a blank thumbnail next to your image layer.

You can use the black brush set to 100% opacity to remove data from the layer, and paint using white to bring data back. If you set the brush to a

Top—As you work with each layer, you can use the Transform functions to rotate and scale the pieces to blend into this soft-edged montage. Bottom—If you have too much of a feathered layer showing, you can add a mask to that layer. Then use the black brush and Opacity options to remove unwanted edges.

small opacity percentage, it will erase only a small portion of the image layer. This is the method you would use to make the fish fins transparent on the background.

If you were to add a gradient to the Layer Mask from bottom to top (black to white), the black part will block most of the bottom of the image, and the white portion of the gradient would allow the image to show through at the top. This would be handy for correcting light falloff problems.

○ ADDING TEXT

Up to now, all of our editing techniques have been applied to raster or bitmap graphics. This type of graphic changes its resolution as the image size is scaled up and down. Almost all photographs fit into this category.

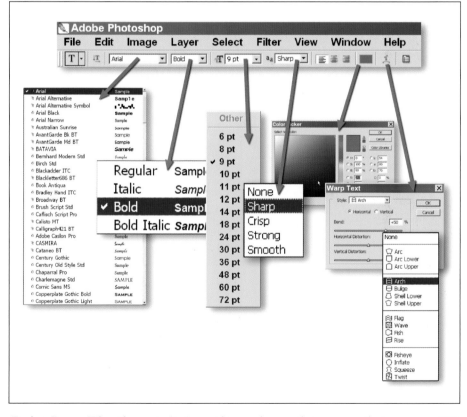

*Facing Page—When the composite is complete, make sure that you save the image as a PSD file, which keeps all the layers and editing intact in case you want to modify it later. **Above—** When you select the Text tool from the toolbox, several options will appear at the top of the editing screen. You can then select the font, style, size, sharpness, color, and shape of the text.*

Above—When you use the Font pull-down menu, the font type and a small font preview will appear. After selecting a font, you can use the Styles menu to modify the font with bevels, shadows, highlights, and strokes. Left—The Character palette has additional options for text style, spacing, and the shape of the font.

Vector Graphics. Vector graphics—type, clipart, and shapes—are different because their resolution doesn't change with variations in image size.

When you select the Text tool from the toolbox, you can type directly on the screen. The new text layer will appear alongside your photographic layer in the Layers palette. At the top of the editing screen, you will find boxes for selecting typeface, size, justification, color, and edge sharpness for your text. You can also spell check your text via Edit>Check Spelling.

Styles. For some real dazzle, you can add thousands of text effects by going to the Window>Styles palette and clicking on the small triangle at the top

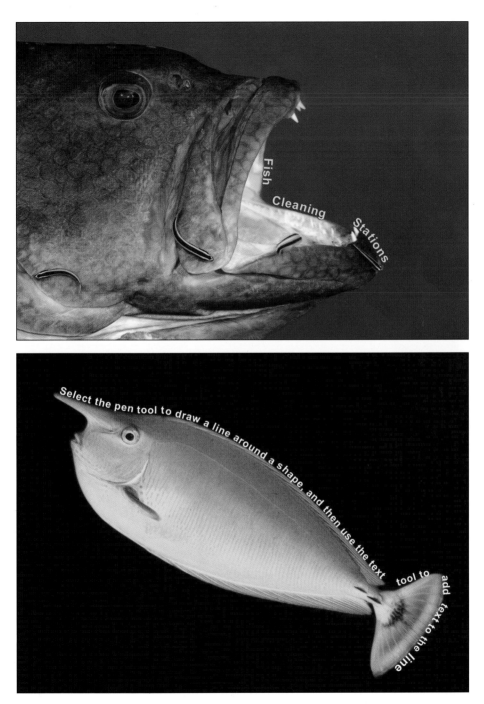

To add a line of text around a shape, first use the Pen tool to draw a line along the edge. When you bring the Text tool over the line, you can type your line of text on that irregular line.

Top—When you want to fill a letter with a photographic image, you must first copy the image, then paste it as a layer above the text layer. When you right click on the photo layer, you can add a clipping mask so that it clips the photo to fill the letter. ***Above***—The composite fish image was copied and pasted as a layer over each letter, then turned into a clipping mask as shown in the first image.

right-corner of the menu screen. From the pop-out window, you can append the text effects (and a variety of other effects for other purposes). You can also load new styles that you obtained from the Adobe download page.

Once the Styles palette is open, all you have to do is click on a style, and it will appear on the selected text on the main editing screen. If you have found a text effect you like but want to tweak it, you can go to the small "f" icon at the lower-left corner of the Layers palette and select a layer style. When the dialog box opens, you can add drop shadows, gradients, etc. If you like, you can also save your modification as a new style in the Styles palette; simply click on the New Style button, name the style, and click OK.

○ **CLIPPING MASK**
You can also add photographic texture to your text using the Clipping Mask. After you have created your basic text layer, add a photographic image on top. Select the photo in the Layers palette, then go to Layer>Create Clipping Mask or Ctrl/Cmd+G. This will clip the photo so that it only shows where it overlays on the text. When you select the photo layer, you can size and position it for best placement. You can also add effects like strokes, shadows, bevels, glows, and more.

After the last clipping mask was applied, a bevel was added to the text, and a drop shadow was applied using the Alien Skin Eye Candy 4000 plug-in.

These images are shapes that each have a layer style applied.

○ SHAPES

A shape or vector drawing is much the same as text except they are vector objects. Custom logos are created in vector-based drawing programs like Adobe Illustrator. Photoshop shapes are located in the toolbox and can be drawn directly on the screen. To maintain the aspect ratio when you add a shape, be sure that you hold down the Shift key.

TO MAINTAIN THE ASPECT RATIO WHEN YOU ADD A SHAPE, BE SURE THAT YOU HOLD DOWN THE SHIFT KEY.

You can apply thousands of style effects to your shapes via Window>Styles. Just click on a style to apply it to the shape. The Adobe download page offers dozens of additional free shape sets, including several marine animal shapes, that can be imported into Photoshop.

17. OUTPUT OPTIONS

You now have edited images, or created a composite, and are ready for the next step. We will now embark on one of the most confusing aspects of the whole process—print output. On the other hand, being able to print your images is also one of the more exciting aspects of this digital revolution. Of course, if you prefer, you can still send your image to the local printer as you did with film, but it sure is nice to print underwater images from the comfort of your own home.

Before you even think about making a print, you need to decide what size paper you will be using. You may find that you will need to resize the image so that it best fits the print medium. Although most printer output programs can resize the image as you make the print, often you get a surprise because what you see in the preview image is not what comes out of the printer. Often this is only because you missed a vital setting in the extensive preflight checklist. We feel that it's better to resize your image in Photoshop before sending it to the printer.

○ Crop and Resize

One of the best ways to prepare an image for printing is to use the Crop tool and then resize the image. When you select the Crop tool, you will notice that there are fields for width and height at the top of the image editing screen. The numbers you type in will lock the aspect ratio as you perform your cropping. For example, if you want to print an 11x14-inch image from a horizontal 35mm film scan, type in 14 in the Width and 11 in the Height field. When you drag your marquee, the tool will crop the image to fit on the 11x14-inch paper. If you leave this area blank, then you can crop your image to any proportions.

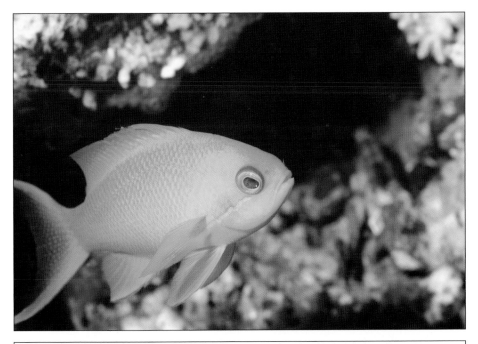

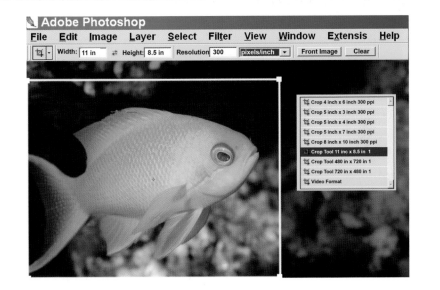

Top—*This digital camera image has been misframed, which resulted in distracting light areas.*
Above—*If you know the crop dimensions that you want for your final image, you can insert the horizontal and vertical values in the Options boxes at the top of the editing screen. When you select the Crop tool and drag the handles to form your new crop, Photoshop will maintain the set proportions.*

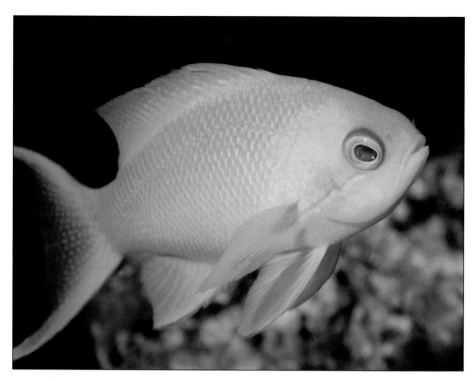

After the image was cropped, the Burn & Dodge tools were used to lower the brightness values in any remaining areas.

○ COLOR MANAGEMENT

Color management for printing sounds like a really great thing, but in reality, it rarely works as well as it should. The reason is that color management systems are based on volume printing, where the system is closely monitored and recalibrated often. The photographer who prints one or two images, skips a month, then starts again may not have much success with an automated color management system. Even so, you should always try the automatic printing systems first to see if you get a good print.

Three Choices. In most printing environments, you can select Let Printer Determine Colors, Let Photoshop Determine Colors, or set the color manually using the No Color Management option. Because the printer-controlled color option has not worked well for us on a consistent basis, we recommend that you select the Let Photoshop Control Color option, as long as you are using monitor calibration and have selected the proper printer profile.

Manual Control. If you still find that fully automated color management is not your cup of tea, then you should opt for the manual setting. This means

Print

Position
Top: -0.089 inches
Left: -9.247 inches
☐ Center Image

Scaled Print Size
Scale: 21.29% ☐ Scale to Fit Media
Height: 8.414 inches
Width: 12.589 inches
☑ Show Bounding Box
☐ Print Selected Area

Print... | Cancel | Done | Page Setup... | Fewer Options

Color Management ▼

Print
⦿ Document (Profile:sRGB IEC61966-2.1)
○ Proof (Profile: N/A)

Options
Color Handling: Let Photoshop Determine Colors ▼
Let Printer Determine Colors
Let Photoshop Determine Colors
Printer Profile: Separations
Rendering Intent: No Color Management
Proof Setup Preset: Working CMYK
☐ Black Point Compensation
☐ Simulate Paper Color ☑ Simulate Black Ink

Above—When you first select Print with Preview, you will be presented with options for image size, cropping, position on the print, and choice of color management. In this case we selected Let Photoshop Determine Colors. Right—If you pick this method, it is also critical that you select the printer profile that best matches your system. Some profiles work better than others, so you may have to try a couple of test prints before you start a major printing session.

that you will have to run several test prints with a selected image that has whites, midtones, and good solid blacks. Most calibration software and hardware programs come with a test chart, and we highly recommend using it when you are manually adjusting your color settings. Once you have a good balance, save the settings, and you should get the same print results from week to week.

Adobe RGB (1998)
Apple RGB
ColorMatch RGB
sRGB IEC61966-2.1
Generic EBU 1.5 Gamma Monitor
Generic EBU 1.8 Gamma Monitor
Generic EBU 2.2 Gamma Monitor
NTSC (1953)
ProPhoto RGB
Pro4000 Photo Qlty IJP
Pro4000 Singleweight Matte
Pro4000 Enhanced Matte
Pro4000 Archival Matte.icm
Pro4000 Premium Glossy
Pro4000 Premium Semigloss
Pro4000 Premium Luster
Pro4000 Premium Luster 250
Pro4000 Premium Glossy 250
Pro4000 Premium Semigloss
Pro4000 Premium Semimatte
Pro4000 Proofing Semimatte
Pro4000 Watercolor - RW
Pro4000 Smooth Fine Art
Pro4000 Texture Fine Art
Pro4000 Velvet Fine Art
Pro4000 Photo Qlty
Pro4000 Singleweight Matte
Pro4000 Enhanced Matte
Pro4000 Archival Matte
Pro4000 Watercolor
Spyder 2 Left Monitor
Spyder 2 Right Monitor
Wide Gamut RGB

Facing Page—*This is the test image that comes with the Spyder 2 monitor calibration hardware (www.colorvision.com). It contains a MacBeth color chart, Kodak color chart, resolution lines, facial tones, and tungsten lighting section. You can also convert this image to black & white to use it for testing the neutral values of your printing system.* *Above*—*As you work through the myriad of printer menus, make sure that you have the paper size set to match what is loaded in the printer. You should also check the remaining boxes for paper source, surface type, borderless settings, and orientation.*

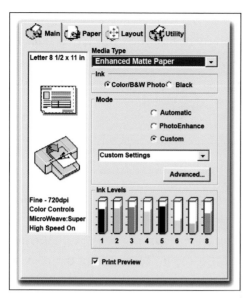

Left—In the main printer menu, you should set the media type, the color mode, and check ink levels. If you try the Automatic mode and are dissatisfied with the print quality, try selecting the Custom setting. It has a submenu that will offer more advanced options. **Below**—*When you are in the Custom or Advanced printing menu, you are given controls for image quality, printer speed, color adjustments, contrast, and saturation controls. Once you have a test print that looks good, save the settings to a file name that best describes the type of print job.*

○ Gamut Warning

If you have a colorful image that is giving you fits when you try to print it, then you just might be out of gamut. Many very colorful images look great on your RGB monitor—but not when they come off your printer. The Gamut Warning can be turned on by going to View>Gamut Warning or pressing the Shift+Ctrl/Cmd+Y key combination to show areas that will be difficult to print. The out-of-gamut areas of the image will be indicated by the color that you have preselected in the Photoshop Preferences>Transparency & Gamut section.

MANY VERY COLORFUL IMAGES LOOK GREAT ON YOUR RGB MONITOR—BUT NOT WHEN THEY COME OFF YOUR PRINTER.

If the image you wish to print indicates a large out-of-gamut area, then just convert it to CMYK, and Photoshop will fix the problem during the conversion. When you convert the file back to RGB, the image will look the same but should print better.

○ Photographic Edges and Framing

In our first book, *Digital Imaging for the Underwater Photographer,* we provided an extensive discussion on the File>Automate>Package Printing command. This function allows you to select from several multi-print formats, and load either one or several images on a page. This program is really great, but there are even more options available with Photoshop-compatible third-party printing plug-ins.

Jump Plug-ins. Many of the printing plug-ins that are available are jump plug-ins. When a jump plug-in is selected, Photoshop is minimized, and these very large and memory-intensive programs process and prepare your images for creative printing output.

More Plug-ins. To really appreciate how much these programs have to offer photographers, pick up a copy of our book, *Plug-ins for Adobe® Photoshop®,* and read the chapter on output. Also, be sure to visit www.Auto FX.com for information on the DreamSuite and Photographic Edges plug-in, or go to www.extensis.com to learn more about Photo Frame. These three programs combined have over 10,000 different formats for your printing options.

We've provided a few examples of some of the effects you can achieve on the following pages.

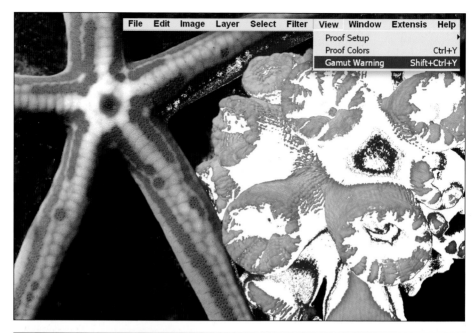

Top—When we turned the Gamut Warning on, we found that there were colors that might not correctly display on output devices like printers. **Above**—The problem can easily be solved by going to the Mode command at the top of the editing screen and converting to CMYK to change the color display of the image. You can then print the CMYK file directly to a printer or convert it back to RGB to print.

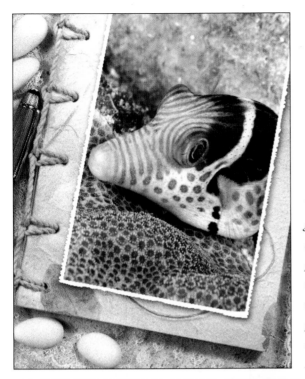

When using the AutoFX Photo-graphic Edges plug-in, you can copy and paste images into special premade templates. The program masks and then feathers the selection for quick and easy creative print output. The images can also be scaled, rotated, and flipped inside these templates.

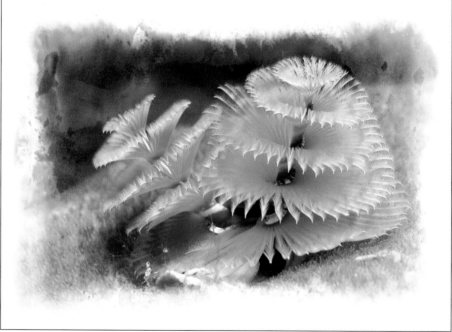

Top—*This film scan image was imported into Photoshop, then the AutoFX DreamSuite plug-in was applied. When the image was pasted into the 2¼ film template, it automatically created a negative and positive of the image and placed them side by side.* **Above**—*You can select from thousands of image frames when you load the onOne Image Frame plug-in. This plug-in creates a layer frame with a mask and allows you full blending control over the frame's edges.*

○ Digital Slide Shows

A very popular method of presenting images today is with a computer-driven slide show program like ProShow Gold from www.photodex.com. These programs enable you to take your still images, put them on a timeline, add transitions, music, narration, and then burn a DVD so you can present them on a TV screen or video projector. These programs make easy work of replacing the ol' slide projector shows.

The downside to computer-driven shows is that the large files used in the presentations can bog down the computer and cause it to run slow. The key is not using your full-resolution files, but rather to scale your images to match the required output resolution. Since the most common image size today for output from a computer is 1024x768, we highly recommend that you create a new slide show image directory called 1024.

Resize Your Files. Create an Action that will resize your image down to a width of 1024 pixels and save it as a JPEG file directly into the new 1024 directory. Run the Action on a second file, and recheck its file size. If everything is alright, then go to the File>Automate command and process all the image files from your main directory that you intend to use in your show. When you

If you want to do a wide-screen video presentation, set your Crop tool to a Width of 16 and a Height of 9, crop your images, and save them to a wide-screen directory.

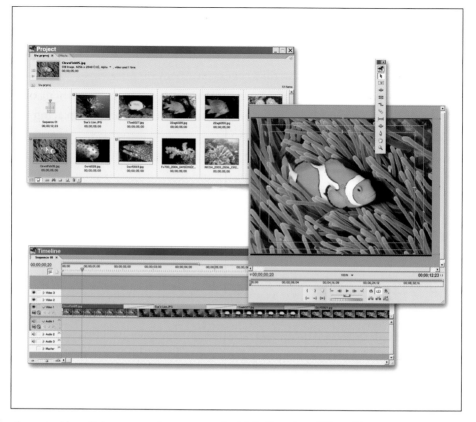

A great video editing companion program is Adobe Premiere. When this software opens, you will be presented with a library (upper left) where you keep your working images, the preview monitor (middle right), and the timeline (bottom). While working on your project, if you find an image needs adjustment, just right click on the image in the timeline and you will bounce to Photoshop for editing. When you are done, the image will be updated and put you back into Premiere.

assemble your show, use these 1024 images, and this will maximize your computer speed, without compromising image quality.

If you find that you want to zoom or pan an image, you will need to work with a larger file to maintain quality. Just go back to your main directory and select the image with the larger file size. This will allow you to zoom in on just a section of the image and still not sacrifice any resolution.

○ VIDEO OUTPUT

Sizing Your Files. If you are editing images for video output to programs like Adobe Premiere and Encore DVD, large files will tend to slow your workflow

down. Some video programs will even choke if the files are too large. Since video resolution is 720x480, you might assume that you would rescale the image to match that size. Since most video productions using still images have plenty of zooming effects, we recommend that you increase the size of the file to 1440x960. This will give you maneuvering room for zooms and pans but will maintain maximum quality.

NTSC Colors. Because the television does not have as wide a color range as the computer, you must limit the image files' colors for proper viewing. You can correct the colors for previewing on television by going to Filter> Video>NTSC Colors. Since you may have dozens of files to correct, we suggest that you make a Video NTSC Action filter so you can batch process an entire directory.

If you plan on using your images in a video production, you should consider looking at the Image>Pixel Aspect Ratio menu. The pixel aspect ratio is different on a computer screen than with video, so you need to apply the appropriate pixel size to your image. If circular objects in your video look flattened, then these settings will solve the problem.

Pixel Aspect Ratio. Another problem with video is the pixel aspect ratio. Computer screens use square pixels, which generally work fine on computer monitors and for printing output. Video output devices use a variety of other pixel aspect ratios that will distort still images that are imported into Adobe Premiere. In Photoshop CS2, Adobe introduced a large selection of pixel aspect ratio corrections that can be applied to your images before saving them for video usage. An Action should be made so you can batch process images and speed up the process.

COMPUTER SCREENS USE SQUARE PIXELS, WHICH GENERALLY WORK FINE ON COMPUTER MONITORS AND FOR PRINTING OUTPUT.

Many times on our dive trips we have heard photographers utter the phrase, "I'll just fix it in Photoshop." Photoshop is a very powerful tool, but we don't consider it an excuse to take bad images. You should always do your very best to get the shot right in the camera before considering what you can do with the image in Photoshop. The human eye—not Photoshop—is the most important part of underwater photography. To become a good underwater photographer, you must become a master of both shooting and editing.

The big advantage of working digitally is that you can see what you are shooting while still underwater. Be sure to take advantage of that, but don't rely on it completely. What you see on the LCD monitor may not exactly match what you see in Photoshop. This means that you will need to synchronize your shooting and editing process so that what you see is what you get. You will need to calibrate your computer monitor and then adjust your camera until it matches.

THE BIG ADVANTAGE OF WORKING DIGITALLY IS THAT YOU CAN SEE WHAT YOU ARE SHOOTING WHILE STILL UNDERWATER.

One of the downsides to digital technology is that it changes so rapidly. It becomes very difficult to keep up, but nothing says you have to constantly upgrade your camera systems. If you are getting great shots, then stick with your current system, even if it's a bit out of date. One of our best images was taken on one of the first 3-megapixel cameras ever made, and its 16x20-inch prints can easily hold their own against any taken with today's technology.

So what about upgrading your Photoshop versions? We have been involved with Adobe's beta testing on all Windows versions of Photoshop and can honestly say that each addition brings new innovations in image editing. We think you should upgrade with each new version, but if cost is a factor, upgrade every other version. If you stay too many versions back, you'll miss out on all the cool new features. Most upgrades are designed to make your image editing faster and easier, resulting in higher productivity.

Another advantage to image editing with Photoshop is that it allows you to reminisce about your diving days, all year long. You can relive the thrill of diving with that cuttlefish as you work on your computer when the snow outside is two-feet deep. This year-round interest in underwater photography generates increased excitement for the sport and keeps diving on your mind.

Working with Photoshop can also be a frustrating experience. It takes quite a bit of practice to master even the easiest of image corrections. Just when you think you have mastered a tool or effect, you see that there is another way to accomplish the same task. The power of Photoshop seems endless. Because we have seen how often it is difficult for photographers to master these editing skills alone, we founded the Oregon Coast Digital Center, a facility offering personalized Photoshop training. For further information, log on to www.oregoncoastdigitalcenter.com.

Finally, we see many new digital photographers getting so wrapped up in all the newly evolving technologies that they forget the real reason for taking pictures underwater is to just have fun. That said, close Photoshop for now—let's go diving!

ANOTHER ADVANTAGE TO IMAGE EDITING WITH PHOTOSHOP IS THAT IT ALLOWS YOU TO REMINISCE ABOUT YOUR DIVING DAYS....

Select books by Jack and Sue Drafahl . . .

DIGITAL IMAGING FOR THE UNDERWATER PHOTOGRAPHER, 2nd Ed.

Learn how to improve your underwater images with easy-to-learn digital image-enhancement techniques. This book shows you how to input, edit, and output your images, use archival storage systems and photo databases, and make a variety of image enhancements—including adjustments to exposure, contrast, and saturation. You'll also learn the skills you need to deal with grain, backscatter, scratches, and other common problems. $39.95 list, 6x9, 224p, 240 color photos, order no. 1727.

MASTER GUIDE FOR
UNDERWATER DIGITAL PHOTOGRAPHY

Learn what it takes to create dazzling underwater digital images, showcasing the beauty of a world that relatively few people have a chance to experience. Acclaimed underwater photographers Jack and Sue Drafahl show you techniques for lighting, exposure, and more, helping you make the most of each exciting dive trip. A must-have reference for underwater photographers of all skill levels. $34.95 list, 8½x11, 128p, 250 color images, index, order no. 1807.

PLUG-INS FOR ADOBE® PHOTOSHOP®
A GUIDE FOR PHOTOGRAPHERS

Supercharge your creativity and mastery over your photography with Photoshop–compatible plug-ins and the tools outlined in this book. You'll learn how to add a wide range of enhancements—from traditional photographic effects to more outrageous and artistic renderings that amplify your images and unleash your creative potential. $29.95 list, 8½x11, 128p, 175 color photos, index, order no. 1781.